About the Author

Michael Paraskos was born in Leeds and studied at the Universities of Leeds and Nottingham. He has written many books, essays and articles on art, literature and politics, and has taught at universities and colleges around the world. Previously Head of Art History for Fine Art at the University of Hull, he has held the position of Henry Moore Fellow in Sculpture Studies at the University of Leeds, and Critic in Residence on the Ad Reinhardt Display at Art Basel 41, organised by the Marlborough Gallery.

He has curated several exhibitions, organised conferences, appeared on BBC radio and television, and is a leading figure in the New Aesthetics movement. He is Director of the Cyprus College of Art in Cyprus, and Research Fellow for Harlow Art Trust in Britain.

Previous books include *Clive Head* (Lund Humphries), *Steve Whitehead* and *Is Your Artwork Really Necessary?* (both Orage Press), and he was editor of *Rereading Read: New Views on Herbert Read* (Freedom Press).

D1514362

Regeneration

Unpublishable Moves
Towards a Position of Principle

Michael Paraskos

The **Orage** Press

First published by the Orage Press in 2010

The Orage Press
16a Heaton Road
Mitcham
Surrey
CR4 2BU
England

ISBN: 978-09565802-0-7

Printed in England by Lightning Source. Set in Baskerville

Part Five of the New Aesthetics.

Contents

. . .

Preface

Regeneration did not start as a manifesto or even a statement of principles. It was a response to being unable to sleep in the heatwave that hit Cyprus in the summer of 2007. For a couple of nights I found myself waking up at two or three in the morning, drenched in sweat and facing the option of either turning on the air conditioning and going back to sleep; or getting up. Had I not been alone in the flat for almost the entire month of my stay in Cyprus I might have done the former. As it was, I reverted back to behaviour that had characterised my adolescence. I got up to have a look at the night. Once that was done, I found myself picking up pen and paper, sitting out on the balcony with a beer, and writing. The result was the first parts of *Regeneration*.

Regeneration is important to me, but not as a piece of writing. Indeed, in some ways it is disjointed, crude and incoherent. But it was also my process of metamorphosis, and through it I turned from someone who lacked almost all confidence in what I had to say about art into someone who had a belief.

To some who know me this will sound untrue. As a lecturer on art, they might assume I always had confidence. My former students, teaching colleagues and strangers who have read my writings might well say I always *seemed* to have confidence. I remember hearing of a conversation between Clive Head and Jason Raven when we all worked in the art school at Scarborough. Jason had apparently said that for the most part I seemed extremely shy and nervous, but when a conversation turned to art I changed. Suddenly I was on home ground and, according to Jason, was full of confidence. Remarkably, he said something along the lines that I seemed to 'come alive'. I must admit I was amazed even at the time to hear of this as I knew it was all an act. In the truest sense of the phrase, it was a confidence trick, but I guess I was simply better able to hide my deception when the conversation turned to art than on other

things. Certainly the truth is that in the summer of 2007 everything changed and I gained a real faith in the value of my own opinion. I came alive. It was one of a series of moments in my life when, I have recognised afterwards, gradual processes of change seem to reach a tipping point and a revolution in how I think ensues. It is probably a good idea to keep this in mind when reading this book, in particular the section *For Your Eyes Only*. You will see it was not the first time I seemed to come alive, or to use a Christian metaphor, was reborn, nor necessarily the most dramatic.

If this sounds like a religious experience, that is not a bad analogy as it felt pretty much like that at the time. It was like the gaining of faith. Faith in art even became one of the central themes running through my writing as it became clear to me that one of the main problems with bad contemporary art is the bad faith it shows in art. To make art is to proclaim faith in the importance and necessity of art, but when people say that anything can be art, that anything is art when an artist says it is art, and that art is not a material object but an idea, then they seem to show bad faith. They are claiming art is something it is not because they lack faith in what it is. The story within *Regeneration* of the Carpenter's Cake is a direct response to this as it is obvious that if we claim anything is art what we are actually saying is that nothing is art. The framework for art is distinct in its own right, and if we do not assert and defend that distinctiveness then art disappears. For me, this has resulted in a realisation that for art to thrive in the twenty-first century the fallacies that dominated the last century, particularly the idea of art in the expanded field, the dematerialisation of the object and interdisciplinary imperative to contemporary art practice, need ousting. The motivation behind these fallacies might have served a useful purpose in the last century, but now they are a hindrance to the production of real, meaningful and engaged art.

So I return to my analogy with religion. It is my belief a new art now can only come about through something like a faith

movement. I mean that instead of trying constantly to undermine art, or the reason for art, or the physical forms that are essential to art, we need a simple faith in the validity of art. The opposite of this has become too easy to articulate so that the interminable process of challenging people's preconceptions as to what art is has become as difficult as kicking a puppy. It has become too easy to destroy faith, and the rewards too great for those who do.

Now, I accept that in the 1920s, when Marcel Duchamp was showing his ready-mades, it was probably a good idea to challenge people's preconceptions about almost everything. Rampant capitalism had just precipitated the First World War, a trade war that had cost the lives of over 20 million people. Over 40 million if you include those who died of disease in the years immediately after it. In the light of that, challenging preconceptions about art might seem a bit piddling, but it was an understandable response. On a much lesser scale, in the late 1960s and 70s, when conceptualism at least had a sense of mission, and most people probably did have a narrow preconception as to what constituted art, maybe the idea of art also needed challenging. Now, however, I wince every time an artist says that something challenges preconceptions because when they say that you know their work will be nothing but preconceived, clichéd and dull. One need only look at a typical Turner Prize show for evidence of this; or a bog standard exhibition at the ICA or Ikon Gallery; or anything presented in the name of Martin Creed. It is an irony that has yet to be faced by the followers of Duchamp that we have reached a point in time when most people's preconceptions as to what constitutes contemporary art is exactly the same as the work that is supposed to challenge those preconceptions. Either there is a very subtle form of irony in all this, or art is failing to live up to its own rhetoric. I suspect the latter, and the result is that if any artist really wants to challenge preconceptions as to what constitutes art now, then they should probably paint a still life or landscape. Indeed, there is a good argument to be made that painting a still life or landscape is the *only* radical thing to do

in the current art environment. In Peter Bürger's oft-cited definition of the avant-garde,[1] the radical dissenting edge of art is anything that goes against the bourgeois mainstream. As conceptual art is now the bourgeois mainstream then the radical avant-garde artist in the early twenty-first century cannot be anyone or anything that is like a conceptualist. Today the radical, avant-garde artist is more likely to be a painter of still lives or landscapes, and the only real question is whether they are any good at it. Most painters of still lives and landscapes are not, which is another problem, but there is still a perverse logic in claiming they are the true radicals.

The point I am trying to get to, however, concerns faith. As the ubiquitousness of conceptualism proves, it is always possible to come up with reasons not to make art, so the response of the artist and the art-lover has always to be a supreme act of faith as to why art should exist. And yet, I need to point out that *Regeneration* is not intended to be a public challenge to the mainstream. It is a private document that only records part of my journey into realising the problem with contemporary art. It is the beginning of *my* understanding of a solution. Most of all, however, it is a record of the growing sense of the validity of my own feelings towards art.

If we are honest, most art is indifferent, so that it would not matter if a particular painting or sculpture or piece of concept illustration did or did not exist. One of the greatest services art departments in universities and art schools could do would be to instil in students a need to always ask the question *Is your art work really necessary?* But as a whole art is necessary, not because it decorates the world, or provides a 'creative sector' in the economy, or even because it gives an income to people like myself who might be incapable of doing much else. Art is necessary because it is essential to human life. Art is the physical manifestation of our sensory response to being in the world, and as such it is one of the primary means we have as human bodies to define, understand and establish consciousness of that world.

Non-art, bad art and indifferent art does not challenge us because non, bad and indifferent artists are incapable of establishing a sensual relationship to the world, which is essentially an aesthetic relationship to the world. At best they establish an intellectual (or conceptual) relationship to the world which is outside of aesthetics, and therefore outside art. Aesthetics is the only basis on which to take a radical position in art, not because it is a polemical position, but because each time an artist establishes an aesthetic relationship with the world a unique statement of existence is created through the work of art. That statement is a singular definition of being that has never been made before, not a commonplace cliché, and the most radical position anyone can ever take in life is always that of the unique individual. There us nothing more radical than this, but concept-illustrators do not even realise this is the foundation of art, and so they are the opposite of radical. They are smug, complacent and ordinary, and they show bad faith in the very practice they claim to be doing. In the face of this, it is only by an act of good faith, and the zealous confidence such faith gives us, that we can maintain a belief in the necessity of art.

Begun in the middle of the night, I hope *Regeneration* has an honesty about it, and that it is not another act of sophistry. This is not argument for argument's sake. Ultimately *Regeneration* is my attempt to be honest with myself. This has resulted in a highly personal document, that sometimes deals with highly personal and even painful things. As a piece of writing it is perhaps little more than a record of how I think, but it also makes physical and concrete some of my fleeting sensations and beliefs. In becoming concrete those sensations and beliefs seem to have become more real and substantial, and better able to take on the task of rescuing art from its false friends. Even so, my views have evolved and moved on since much of this was first written, although I have resisted as much as possible the urge to change things in the text because of that. Most of the changes that have been made are cosmetic, relating to the readability of something that was previously unreadable in places.

My initial thought was that *Regeneration* was too personal ever to become a public book −that is to say it was unpublishable except as a private printing for a few friends, many of whom have experienced a similar journey to my own. Most of those friends are practising artists, and so their journeys will be recorded in their art works rather than words, but there are writers amongst the visual artists too. If their work and mine is taken as a unified body of criticism then the result might be a base-load of practices and thoughts that can lead to public exhibitions and statements that are capable of spreading the new faith. And that is why I changed my view on publishing this work. You are welcome to disagree with my decision, and you can judge what I say here with a harsh eye if you must. But unlike a great deal in the mainstream art world, do not doubt its sincerity even if you reject what I have to say. You would be wrong to reject what I say, but you always have that choice. And it is a choice you have to make; do you believe in art, or do you not. And that really is a question of faith.

As always, I am indebted a number of people for their assistance, most notably Clive Head, whose comments on the text were astute and invaluable, but also for his long discussions with me on the nature of art. Also Emma Hardy and Ben Read for their support, and the students and artists of the Cyprus College of Art, on whom many of these ideas were road tested.

Part 1: Poor Professor 'Iggins

My name is Michael, and I was an art historian. I did not intend
for this to happen, and it came as much as a shock to me as
anyone else. When I first went to university I had every intention
of becoming a writer, a poet to be precise, and with that aim I got
involved in the students' poetry magazine and tried to get to know
the tutors in the School of English. Unfortunately the School of
English was overwhelmed by shitty tutors at that time, and I was
inevitably repelled by them. The Department of Fine Art seemed
far more enticing, even though there were some unpleasant
characters on its staff too. There was also a more serious
obstacle, the feeling I had from the start of my studies that I was
at odds with the philosophical approach that dominated Fine Art
in Leeds. In the circumstances it was a miracle I felt so much
more at home there, but then it was still an art department, I
understood the type of person who inhabited it, and very
occasionally you could even smell some linseed oil and turpentine
being used by a rebel painting student amongst the troop of
conceptualists. I will not say I had an entirely happy time there, I
didn't, but these things are always relative, and relatively
speaking I was less unhappy in Fine Art than I was in the School
of English.

Intellectually, however, the disagreement I had with the
dominant philosophy of the Fine Art Department was a good
thing. It turned me into a dissident, and for that alone I shall be
eternally grateful to the Department of Fine Art at Leeds
University. Its dogmatism turned me into a free thinker.

I suppose most people consider themselves to be free thinkers,
and for free minds all things are open to discussion. Unfortunately
discussion is not a defence against misunderstanding, and there is
no greater proof of this than the misunderstandings that surround
art. Indeed, there is a lot of discussion around art and a lot of
misunderstanding.

As you might have noticed just then I wrote the slightly ungainly phrase 'around art' rather than the more standard 'on art'. This is because, although there is a great deal of discussion around art, very little of it has anything to do with art itself. We might hear a great deal on the financial value of a second-rate impressionist pot-boiler sold at auction, or a rich-man's plaything allegedly designed by Jeff Koons; and every now and then the popular press likes to pretend it is outraged by some exhibition put on by an Establishment lackey. But in these instances the discussion of art is minimal or non-existent. In fact, the level of debate on art is at one of its lowest points in modern human history. One only has to look at the difference between the quality of discussion in a popular art magazine such as *Studio International* in the 1960s and 70s and the equivalent in the mainstream art magazines of today, such as *Frieze* or *Art Review,* to see how little discussion on art there really is. Like substandard gossip columns, art magazines have become nothing more than places to expose celebrity artists or pump up the next round of predictable biennials. One might as well buy *Hello!* magazine.

Some of the worst offenders in this are the very people one would expect to discuss art most of all, art historians and critics. It is true they do use art more than most, but in the way they use a work of art they still only talk around it and not on it. For the art historian the primary use of an art-object is as an illustration in a book or lecture to whatever contextual point they want to make. They will discuss what they think of as the 'meaning' of the art work a great deal, but they rarely touch on any discussion of art itself.

For example, if an art historian wanted to make a point about Marie de Medici not being a popular choice to become the Queen of France they might show the painting by Rubens entitled *Marie de Medici Arriving at Marseilles.* In this Rubens depicted Marie de Medici being welcomed at the port of Marseilles by representatives of the French people. However, the art historian's interest in the painting is nothing to do with the astonishing artistry Rubens employed in

making this huge beautiful object; it is in the painting's contextual or narrative value as a propaganda piece, commissioned by the supporters of Marie de Medici to boost her position in France. For the art historian this contextual point is then driven into the painting, becoming its meaning. This results in the art historical meaning of a work of art having nothing to do with art. That is to say it has nothing to do with the artistry of the art work. It is solely a question of the painting's status as an illustration to history. The art work's meaning becomes solely its context.

In a similar way, an art historian might want to say that France was subject to rapid industrialisation during the nineteenth century, and this resulted in a great deal of social displacement. Consequently many people felt alienated from society. To make this point they might show Manet's *Bar at the Folies Bergeres*, with its bored looking barmaid. Her boredom equals social dislocation. This use of the *Bar at the Folies Bergeres* as an illustration to history forces us once again to think that the meaning of the painting is the alienation of industrial France, rather than the level of artistic skill and creativity that Manet employed in its production. Once again the painting's status is defined solely by its ability to illustrate history or the context that the art historian wishes to discuss.

This was not always the case, and certainly before the 1970s art history comprised a more diverse set of approaches to the discussion of art as well as the context around it. The very term art history was contested, on one side by what was meant by history, and on the other by whether the subject was a history of art, or a psychology of art, or simply the appreciation of art. This meant that contextual histories of art, also known as social histories of art, pioneered by people such as Frederick Antal and Arnold Hauser, existed alongside the psychological approaches of Herbert Read and Adrian Stokes, and the connoisseural approaches of Kenneth Clark and René Huyghe. There were other approaches too, and the subject possessed the healthy vitality one would expect of such a pluralism. However, in the

1970s the subject changed dramatically, ostensibly because of the rise of a phenomenon known as the New Art History. The New Art History was primarily a Marxist phenomenon, although it encompassed other social theories of culture such as feminism, and it was led by figures such as T.J. Clark, Charles Harrison and Griselda Pollock. Earlier Marxist theorists had argued that the primary way to consider art was as an illustration of its social context, but what was new about the New Art History was the way this approach was coupled with an all out assault on the very existence of any other approach. Whilst an old Marxist writer on art such as Hauser could acknowledge the relevance of a non-Marxist writer like Read, his latter day equivalents, such as T.J. Clark, could not. Instead, New Art Historians presented the 'old' art history not as a pluralism in which their views were also represented, but as a singular and outmoded way of looking at art that would be superseded entirely by the New Art History. All those different views in the 'old' art history were characterised as if they were the same thing, so that future art history students were misled into thinking the art histories of Read, Stokes, Clark and Huyghe, and even the old Marxist art history of the likes of Antal and Hauser, were one and the same. Instead of being a healthy pluralism, the 'old' art historians were characterised as a bunch of male old farts who cooed over pretty pictures and used the most flowery language possible. All of this was a very clever move on the part of the New Art Historians and is a lesson for anyone wanting to stage a putsch. Simply set up a simplistic caricature of an existing reality (the 'old' art history), making sure that this caricature is an easy target to attack (the 'old' art history was purely connoisseural). Then dismiss it furiously whilst presenting ones own views as different and new, even if they are not.

With the New Art History sweeping away a pluralistic world of art criticism, the confusion of the meaning of art with the context around art continued apace. With the parallel development of Marxist-inspired literary theories in France, called

Structuralism, this approach soon came to see the meaning of a work of art as residing solely in the contextual structure that surrounded it, not the artistry, quality or materiality of the thing itself. The word context is important in the New Art History because it suggests something that is not fixed. The context of a male member of the bourgeoisie looking at a Manet painting in the 1870s is different to the context of a female member of the working classes looking at the same painting in the 1970s. The context of a black person looking at the painting is different to the context of a white person looking at the painting; and the context of a Christian is different to the context of a Muslim, and so on. Whoever we are, we bring the context with us to the art work. Context is, therefore, in a state of flux, which means meaning is in a state of flux. The result is that every work of art is a *tabula rasa*, an object in possession of no existence in itself. And that was the dominant political position in my university Fine Art department. Each art work was seen only as the distorted reflection of the diverse possible cultural, political and social contexts or narratives brought to it by its viewers.

I could never hold with this partly because it went so wholly against my experience of art, but also because of its internal lack of logic. It was an approach that gave art history an impossible paradox to resolve. The *raison d'etre* of the New Art History, and much of the 'old' art history, was to ask *What does it mean?* That is, to ask what is the social, historical and contextual meaning of a work of art. And yet just as all art historians began to ask this question they were also being forced to accept that art works were incapable of carrying meaning. The effect of this was, and is, devastating. For decades now, endless possible meanings have been thrown up by art historians in books, articles and conference papers, but each has lacked authority and conviction because their authors do not believe in absolute meanings. A few brave souls, such as Jules Prown, tried to stand against this,[2] but effectively a black hole has appeared at the heart of the subject, sucking in all attempts to explain the meaning of art. I suppose we should pity

the poor art historians who live on the edge of this abyss, in a state of perpetual angst, bearing witness to the meaninglessness of their own existence, and it is certainly no surprise that so many of them are on medication. Indeed, they behave like schizophrenics. Often they will spend months at the start of every art history course in the country, torturing students into accepting that all meaning is a myth. Then, once this is done, they seem genuinely baffled why these same students show such little enthusiasm at the idea of spending the rest of their lives exploring the meaning of art. *Of course they lack enthusiasm, you have just told them to search for meaning when meaning is meaningless!*

As this demonstrates, art historians show bad faith in their own subject, which means art historians lack faith in art history. We can see ample proof of this by the unseemly rush at the moment to rename art history programmes 'cultural studies' or 'visual studies'. This renaming is of interest in itself as it demonstrates how art historians continue to live in the same state of denial about their own history that characterised the New Art Historians' take over of the subject. They continue to refuse to accept any blame for the bad development of their subject, still pinning blame on the long dead 'old' art historians, and increasingly on artists.

> *The false friends of art and their artist conspirators have misled us poor art historians into thinking art is something special. Dirty bastards! Had I known art was so unspecial I would have studied accountancy. As revenge for this evil plot we have decided that we are not going to look at art any more (so we cannot be called art historians). Instead we will look at advertising and crisp packets and neon signs and tabloid typography and anything else that is not art. (What do you mean artists have been looking at such things for a century or more?). We former art historians will now study 'the visual'.*

Yes, you will do this, but only to hide your own failings. It is the temporary crutch to your failing subject.

As a lapsed art historian I would suggest art history needs to acknowledge its failings. The real implication of the New Art History was not what everyone thought it was, that art has no fixed meaning. Rather it was that the question asked of art, *What does it mean?* was wrong in the first place. It was wrong before the New Art History and it is wrong after it. Going on to now ask this same question of every non-art bit of visual culture in the world will not solve the problem, it will merely extend the range of things we can be wrong about. Indeed, given that the fluidity of context has now been hypothesised *ad nauseum*, continuing to pin down the question of meaning to a particular time, place or social group seems particularly desperate and spurious. It is like shipwrecked sailors clinging to barren rocks. The art historians' response to the discrediting of contextual meaning is simply to extend the question *What does it mean, to whom, when and where?* But this masks what is really needed, namely a heartfelt self-questioning of the subject as to whether the question of meaning was ever the right thing to ask of art the first place. The subject's question should be *How can we replace the question of meaning?* Had this been asked two or three decades ago when it was obvious there was a problem then there would have been a chance that art history would not have become as irrelevant as it now seems. Unfortunately, the New Art History promised a false dawn and delayed this self reckoning to the point where it might now be too late. Art history has become as futile an academic subject as it is possible to find.

I have a personal sense of the futility of art history from having done it, but more especially from having taught art history to non-art historians, especially practical art students in art schools. Most art historians are secretly frightened of the people who make works of art, whether they are art students or artists, as it is rather like being an academic bullfighter who has only read books on being a toreador suddenly finding themselves face-to-face with a real-life snorting bull. There are a small number of us who actually prefer teaching art students and talking to artists.

We are of course very brave people, very like toreadors willingly facing the snorting bull. And we are the better for it. But the rest of the art history community treats us with a mixture of pity and contempt. No doubt this is because we have discovered the truth. Art students gain no real insight into art from trying to discover the social, political or ideological context of the production of art. When it comes to art, art historians ask the wrong questions and get the wrong answers. They base those questions on a fundamental misunderstanding of the nature of art, but most art historians are unaware of this. They know there is a serious problem with their subject, evident from falling recruitment onto art history courses, the blurred academic boundaries and the failure to identify an art historical agenda; but their response has only exacerbated the problem by removing academic art history even further away from art practice. They have renamed their subject and are increasingly less interested in talking about art. This has meant that art history is now so far removed from the needs of art practitioners it has become a health hazard to any art student who is forced to study it. For most it is a waste of time, but for many the removal of faith in art's ability to possess any real meaning destroys their motivation to make art. If any subject ever proved that scholarship is the enemy of romance, it was art history. Art historians have turned themselves from the essential gatekeepers of the joy and wisdom of historic art into the tiresome corrupters of youth, and their corruption all stems from that wrongheaded question they ask of art, *What does it mean?* This question is not wrong because art works have no meaning, but because it makes an assumption about art that is inherently false. It forces onto an art work a narrative meaning often borrowed from literary theory that is alien to the discourse of art, or what I would rather call the framework of art.

We can see this for ourselves by asking the question *What does it mean?* of something with a very clear narrative meaning. For example, what did it mean when Jesus said it would be easier for a camel to pass through the eye of a needle than it would be for a

rich man to enter the Kingdom of Heaven? In this case it seems perfectly legitimate to ask *What does it mean?* and the answer comes quite easily. As we all learned at school, it means the rich will never have a place in heaven. With an art work, however, the same question leads to a false answer, to a meaning based on seeing a painting or sculpture as a narrative or story board. For example, by asking that question, *What does it mean?*, of Manet's *Bar at the Folies Bergeres*, we transform the painting into an illustration of the story of alienation in nineteenth-century France. It is no longer a physical art work, with a meaning embodied in that physicality. It becomes no more than a signifier of something that is outside of the physicality of the art object. It becomes disembodied. Of course, we can make such narrative meanings more complex by adding into them a discussion on the changing nature of the narrative over time, or between different people, or different genders, but that question always forces the art work into acting as an illustration to a social narrative rather than a work of art.

Art functions in a different way to illustration, and it should be very clear to anyone with a genuine interest in art that it is not part of the literary-narrative discourse. As we can see from the example of the saying of Jesus about the rich man and the eye of the needle, the literary-narrative discourse is important in its own realm, but that realm is different to the one of art. Art functions within a material or aesthetic framework, and because of that, asking of a work of art *What does it mean?* is just as bizarre as asking someone what their legs or ears mean. We cannot say that art has no meaning, any more than we can say our legs or ears have no meaning, but only the most tedious sophist would think it legitimate to ask of those legs and ears *What do they mean?* The same is true of art.

Early art historians were aware of this, and launched the subject very much as a discussion on aesthetics, which is to say, as a discussion on sensory experience. Indeed, this maintains the analogy I have used with parts of the human body, as we do not ask what our legs and ears mean, rather we experience, in a

sensory way, what they are, just as we experience art in a sensory way for what it is. The only real difference is that we call the experience of art by the academic name 'aesthetics', which actually means 'feeling with the senses'. Art must be a material, physical and sensory phenomenon if it is to be art. Anything outside that framework might be good, bad or indifferent, but it is not art. It is something else, and just as carpentry is as important in life as baking, we do not, as a general rule, confuse the two. In art, however, we do confuse the framework of art with the framework of narrative, and the development of art history, theory and criticism has actually been to deny the relevance of this aesthetic framework, replacing an aesthetic understanding of art with a social illustration understanding that now dominates the contemporary art world. We have reached the point Susan Sontag dreaded, where art ceases to be an aesthetic phenomenon, and turns instead into what she called a hermeneutics. As Sontag so rightly suggested, the solution to this was that in place of hermeneutics we need to develop an 'erotics of art'.[3] Sadly, however, there is very little eroticism in art history, despite art historians seeing more naked bodies in the course of their work than almost any other profession except a brothel madam.

I doubt many standard art critics and historians would agree with me that we should abandon the search for meaning in art. But then I am not interested in discussing art with standard art critics and historians. As the saying goes, *Some of my best friends are art historians*, but I wouldn't let my daughter marry one. Instead I would like to join with those artists and art students who want to start a reformation in which we reclaim art from its false friends. I accept that words like 'reformation' carry with them unpleasant associations with religious history, and in some minds might imply a dogmatic intolerance towards other opinions. And I admit, the idea of tying a few New Art Historians to the stake has an appeal, particularly those associated with the Open University; but unlike the last lot of protesting reformers we are not out to scourge the senses or destroy anything that is beautiful. In our

reformist revolution we will resemble Protestants only in so far as we will no longer need the help of those second-rate padres of art criticism to intercede on our behalf, interpreting the signs and reading the narratives of art for our enlightenment. They have not proven very good at the job anyway, and are an irrelevance to art and society. We will leave them to get on with what they do, so they can continue, if they want to, to look for the hidden meaning of art in their cloistered monasteries, like baffled alchemists trying to solve the mystery of transforming base metal into gold.

For us the reformation will lead to a new exploration of art, rooted here on the ground, in the studios of artists and in the few remaining free art schools; it will happen in places that are inevitably physical, earthy and concerned with the materiality of life.

Nice words perhaps, but it leads me to the 'Laura Solution'. Laura is an art student from Liverpool who began painting here in Cyprus this summer, despite a daytime temperature of 45 degrees in the shade. In that heat you don't even want to move, let alone paint. Laura too said she didn't want to paint, not because of the heat, but because as an art student that is not what she does. But after a while she did start to paint, because somehow it felt right in this place, in earthy, sensual Cyprus, in temperatures of 45 degrees in the shade. And Laura said she enjoyed it. I suggested this was because painting was a physical and material activity and in this place, in these temperatures, no one can forget we are all physical, material animals. We cannot forget we are human. 'Yes', she said, 'but sometimes I wish you art historians would just stop talking and try making something'. So I made her a cup of tea. When she left Cyprus Laura gave me an unfinished canvas with a note pinned to it. It was a challenge: 'Stop being an art historian for a moment,' it said, 'and see if you can finish my painting'. I did –very badly– but I did, and it felt good. I am not an artist, but I have never called myself an art historian since then.

Part 2: The Carpenter's Cake

As we have seen, in art the issue of meaning is very different to simply answering a question. To most questions we expect a definitive answer, but art does not give us such answers. With art our position is more like that of the inquisitive six year old who drives its parents to distraction by always asking *Why?* We are never satisfied with the answers we are given, whether those answers are full explications or more like the parents' exasperated 'Because!' So we always go back to ask the same question again and again. We and our ancestors have been doing this for 20,000 or maybe 100,000 years. That is why art, even if the term did not exist in the past, and the nature of the artist was profoundly different, has been around for so long.

I was recently asked if I thought conceptualism was a passing fad. It was a strange question given conceptualism is itself a very old, not to say old fashioned, movement, but off the cuff I replied that I doubted it would exist in the same way in a thousand years time. But, given its track record, I am not so sure I could say the same about art. I suspect art will be around in a thousand years in a very similar way to now, even if new cultural forms come into existence. The reason I doubt conceptualism will survive that long is simply that conceptualism only ever tries to answer simple questions, and as a simplistic phenomenon those questions are tied to specific periods of time. Take for example the question of the war in Afganistan. A lot of conceptual work or concept-illustration tries to address the 'question' of Afganistan, but that question is something that only belongs to this moment in time. It is disingenuous to claim otherwise. Once that question is answered, usually in a form like 'the war in Afganistan is a bad thing', the conceptual work is redundant. It has answered its own simple question. We might question whether such an elementary question was ever worth asking, and equally whether the answer was worth waiting for, but nonetheless the concept-illustrator sets up

this simple question and gives a simple answer to it. Unlike conceptualism, however, art is a quest for meaning that is based on a constantly shifting series of relationships, between the artist, the material from which they make their work and the material world they encounter 'out there'. There is no predetermined question that has a predetermined answer, only a shifting set of relationships. This is the framework of art, or the aesthetic framework, and once the viewer is thrown into the mix, we have such a complex and fluvial set of relationships we can never really provide the definitive answer to that interminable childlike question *Why?* Why do you present the world in this way? Why do you show me that tree looking like that? Why do you create a version of the world that is so different to the one I seem to experience? Within this framework the sole discussion is on the veracity of an artist's statement on the nature of existence. That is to say, do we believe what the artist presents to us? Does the art work succeed in creating existence? Does it ring true? These are the real questions of meaning we ask of art. In essence they are questions of veracity.

Veracity is a kind of meaning that differs greatly to the question what is a work of art about. Although a predetermined story or narrative meaning might be present in a work of art, it is not essential to it. Often an artist will be motivated by a desire to create an art work about a particular subject or narrative, such as a social or political event, or a story in a religious text, a poem or a novel. But these are simply matters of motivation. Speaking to some artists I am aware that it is important to them that they have such motivation if they are to maintain interest in their own practice over time, but that motivation is often a lot slighter than people imagine. It is not always that the artist wants to capture or express the horror of war, or the futility of existence, or the spiritual ecstasy of their religious beliefs. Often they cite something as seemingly inconsequential as the way light reflects off different surfaces. Perhaps it is the ability to create space and place things in space. A sculptor might talk of the relationship of objects.

Perhaps they are motivated by a boyhood love of aircraft. The possibilities are endless, but they are not always as interesting to other people as we would like to imagine. They are the personal story-narratives that motivate artists to keep making things, but these motivations are not the art. One artist I know has very specific memories from his childhood in mind when he paints his pictures, but when asked later what the paintings are about he often cannot remember. It is like trying to remember a dream he says.

Fortunately, these motivating forces are not essential to art. Art is something far more primal, and although it might use a personal story-narrative as a carrier, the two are not the same thing. That is why the subject matter of a Morandi is so dull, and the motivating force behind Kandinsky so crazy. Nonetheless, we enjoy their art and both are great artists. So, rather than story-narratives, the primal essence of art is best thought of as a response to existence. A better way of phrasing this might be to say that art is an engagement with existence, or even a statement of existence, but this just shows up the paucity of language when trying to talk about art. What art does is question what it is for a human being to exist in the world. It helps us to redefine our understanding of that existence, and the question of veracity is whether we believe in that redefinition.

I can think of an example of art being a response to existence in this way as I look through my window here in Cyprus, out of which I can see a tall cypress tree about one hundred yards away. There are many of these trees on the island, but when I look at them the question I never find myself asking is what is their narrative meaning? The question that arises is far more primal, and concerns my faith in the veracity of what I see. It is a question almost impossible to put into words, but the closest statement to it, I suggest, would be *Is it true?* This question is a sensory response to the collision of my faith in my own existence here and now and the tree's intrusion via the senses into that existence. Its presence forces me to reassess myself, and its

existence changes the nature of my existence as we are now in a spatial relationship with each other. Artists will understand this, I think, from the way the spatial relationship of one figure in a painting or sculpture is changed dramatically by the inclusion *(or intrusion?)* of another figure. Put two figures into an art composition and there is a set of dynamic relationships between them that need to be resolved. Add a third figure, or a third element such as a tree, or a chair or building, and these relationships demand a new resolution. Because my reaction to the presence of the tree I see here in Cyprus is a sensory response it inevitably operates within an aesthetic framework, and because of that it is an aesthetic framework that is similar to the aesthetic framework that governs our response to art. There is a difference, but it is not necessarily as crucial as one might imagine. When I look at the cypress tree outside my window and I look at one of van Gogh's painted cypress trees the difference is primarily a matter of how conscious I am of the questioning process. The discussion over whether the tree outside my window is true is a hidden questioning, whereas the discussion over the veracity of one of van Gogh's trees is manifest. The cypress tree outside my window is accepted in some part of my brain as reality, probably through familiarity, and so any discussion as to its believability is buried deep inside. To all intents and purposes it appears on the surface as though there is no discussion. With a painting, however, the discussion is always present. This is because the art work is itself a physical manifestation of that questioning, and art forces its viewer to confront something that has come out of another person's experience of existence. As Coleridge noted, the difference between reality and art is that art filters reality through a human mind, a process Herbert Read described as reality passing through 'a kind of mental alembic'.[4] When we look at a painting we are forced to question the veracity, or believability, of a filtered, or perhaps partial, reality, and we are asked overtly to decide whether the artist's experience of existence correlates in any way with one we accept. It is possible that the answer we give as a society to this

question when faced with a work of art (and perhaps even the answer we give as individuals) is the basis on which we can return to the question of qualitative value in art ¬so that the vacuous free-for-all that has led to the abandonment of quality in art is replaced by answers such as *yes, it has veracity*, or *no, it lacks veracity*, indicating an art work's good or bad quality.

I should perhaps add that I have no doubt that the mechanism by which the suppression of the discussion of veracity of objects in life does sometimes break down. We even have an idiomatic phrase for it: *I could not believe my own eyes.* But this is a rare event. When it does break down, reality itself might well be operating exactly like a work of art, prompting in a manifest way the question, *Is it true?* A common example of this, for me, comes from an airport located not very far from here. The believability of the huge metal aircraft that take off and land there, especially when they seem to move around the airport so slowly in the sky, is difficult to accept even when I see it with my own eyes. Then I am aware I really am asking of reality *Is this true?* When such things happen I cannot help thinking we are experiencing something like the original purpose of art as a biological function of the human brain, evolved to question and establish reality, and force early humankind to start the discussion *Is it true?* That discussion is surely the origin of consciousness.

One of the strengths of our early ancestors was, of course, their sociability. It is a primal trait we maintain to this day. Despite all claims about artists being lone geniuses who are shunned by society, art is also a profoundly social activity. Indeed, for most of human history the figures we would identify today as artists have been central to daily life, something that was as much true of Victorians artists as to the shaman of early hunter-gatherer societies. Art is always a social activity because the discussion that starts in the silent glances made by one human being as he or she looks for the first time at an art work made by another human being is a discussion as to whether one person's experience of existence in this beautiful but terrifying world is

anything like another person's experience of existence. To look at a painting or sculpture, or even a work of decorative art, is an attempt to answer the fear that haunts us all, *Am I in communion with others, or am I alone?* Yet, in asking this question through art today, we encounter a serious problem. It is the problem of the lack of a shared art-framework. To ask such questions and start such a discussion we have to agree that art operates within a certain framework. Given that I will inevitably be queried on my use of such historically-specific terms as 'art' and 'artist', perhaps we should call this a shared aesthetic framework. Either way, if we do not agree to share this framework then the discussion makes no sense.

* * *

As anyone reading this might have realised my surname is Greek, and half my family comes from the Middle East, from Cyprus. Cyprus is in a part of the world where things are often explained through stories, so let me tell you a story now. It is a story called *The Carpenter's Cake.*

Once upon a time there was a carpenter. He was a man of many skills, and could make you a table that looked like a table, a chair that looked like a chair and even a bookcase that could hold books. All his friends said he was a very good carpenter, but still he was unfortunate because he had no job. It seemed no one wanted to employ a carpenter with his talents any more.

One day the carpenter decided enough was enough. Finally he was going to get a job, and so he gathered together the best pieces of wood he could find and began sawing and carving them into shape. Working all day and well into the night, he formed the most wonderful table he had ever made. What a table it was! Not only did it have four legs, but it had top on which you could place a cup or even a plate. The carpenter had also carved the legs of the table with irregular patterns, and when he had finished his woodwork he had painted the whole thing in a beautiful, if subtle,

shade of brilliant white. It was a table that would surely astonish anyone who saw it, and anyone who saw it would surely give the carpenter a job. What a work is man! What a work this table.

After such a long day the carpenter went to bed and fell into a deep sleep with his plans to hunt for a job next morning filling every inch of his head. The table would guarantee him success he thought as he left consciousness. As the full moon gazed in through the window, casting her eerie light on his dozing head, the carpenter had wondrous dreams in which the table seemed to come alive with possibilities. At one point he thought it gained the power of movement, and walking on all four legs, it came up the stairs and into his room. Once there, like a cavalier mounting a white charger, the carpenter climbed on its back and let it carry him through the window and into the night. Together they visited mysterious lands and had great adventures, rescuing damsels in distress, slaying dragons and finding ancient treasure trove. The table flew through the moonlit sky and the carpenter flew with it.

At dawn the sun rose and the carpenter went downstairs to see his table. It was still where he had left it the previous night, and showed no signs of the adventures of his dream. So he packed it up and carried it through the streets looking for work. At first he called at all the carpenters he knew and showed them his table. They all agreed it was a remarkable sight, and they praised the way he had given it four legs. He demonstrated the top by placing a cup and a plate on it and the other carpenters smiled and said they thought this a wonderful feature. But no one offered him a job. So he went further afield, to other carpenters in the city, and in the neighbouring city and on to the cities after that, eventually covering the whole country. But still no one would offer him a job.

After many days of searching the carpenter was dejected and, with head bent down and low, began his long journey home. It was late evening and the moon was in the sky, a full moon just like the one on the night he had made the table, the night of his strange dream. He had been away an entire month and wanted to

go home. But, as he was about to leave the city he passed a baker's shop and for some mysterious reason he stopped. At first his thoughts were to buy some food for his journey, but as he passed through the baker's door another thought crossed his mind. The baker stood behind the counter, a large jolly fellow with bright round eyes and curving moustaches. He looked just like the gingerbread men that lay on the counter. To the left of the baker's shop there were the racks of bread, most of them empty at this late hour. To the right was a display of cakes, in pretty pastel colours, some of them with lacy trims of sugar ice and plump marzipan fruits that tricked the eye.

'Good evening', said the baker. 'How can I help you?'

'Good evening', replied the carpenter. 'I wonder, do you have any work that I could do for you?'

The baker looked at the carpenter for a moment and wondered why this man had such a rickety old table strapped to his back. He saw it had four legs, each a different length, and so badly carved that if you touched them you would surely find splinters in your hand. The table top was warped and stained with mildew. It made him shudder to think anyone might put a cup or plate on such a dirty piece of wood. And he looked at the man, so tired but clearly keen to work. Eventually the baker said, 'I do need help. I need someone who can bake gingerbread men and bread and cakes. I need a baker. Can you bake cakes?'

'Of course I can bake cakes', said the carpenter. 'Look, I made this table'.

The baker looked confused. 'But that's not baking', he said. 'Surely it's carpentry'.

'Ah', said the carpenter. 'If I might say so, that is a very old fashioned point of view'.

This story came to me after reading an interview between the art critic David Sylvester and the American sculptor Robert Morris, recorded for the BBC in March 1967. In this interview Morris stated, 'Art, I think, has to be defined as anything that's

used as art.' This is a relatively gentle version of a doctrine that has come to dominate the mainstream art world, but which has destroyed any sense of a common aesthetic framework in art. It had its earliest origins in the anti-art proclamations of Marcel Duchamp, the guiding light of the Dada, Neo-Dada, Conceptualist and Neo-Conceptualist movements, and the concept-illustration that dominates today. *Art is anything that is used as art.* More aggressive versions of it do exist, of course, with Donald Judd claiming that 'If someone says it's art, it's art', but as with all statements issued with such dogmatic certainty, we know this cannot be true. Saying a table is a cake does not make it a cake, and saying non-art, such as conceptualism or concept-illustration, is art does not make it art. In acting as if it does, however, we have destroyed the common aesthetic framework in which art operates. Without a common aesthetic framework we have privatised the experience of art, and as a result the social communion has broken down. If I say this is art, it is art, so equally if you say it is not art then it is not art. The result is that a discussion on the veracity of any expression of existence cannot commence because we do not share a framework in which to have that discussion. In my story, to make a cake one has to work within the framework of baking or perhaps cookery. The framework of carpentry is so fundamentally different from baking that it is ridiculous for the carpenter to suggest his table is a cake. Yet, if we follow Judd then *if someone says it is baking then it is baking.* As an intellectual exercise certain branches of idealist philosophy might well argue that a table can be a cake if someone says it is a cake. Perhaps even linguistics might get involved with a discussion on the construction of the identities of tables and cakes through language. But that is sophistry. If I went into a furniture shop today and tried to eat a table or bookcase claiming them to be cakes, or if I went into a cake shop and sat on a gateau, I would not be taken seriously. I would probably be taken to the mental asylum. So why, when I go into an artist's studio, or an art gallery, or an art school, and I see things that are clearly not

within the framework that is art, am I expected to treat what I am looking at as if it is art? Why is art the only human activity in which it is possible for someone to claim a table is a cake?

I suppose one of the reasons is the question of artistic freedom. As I said before, we all like to think we are free thinkers. During the nineteenth century, mainly in mainland Europe rather than Britain, the question of freedom of expression was paramount in many artists' minds. This was primarily because the framework of art was very narrowly defined. I exclude Britain from this because, despite the claim of Paris to be the historic hotbed of artistic freedom and experimentation, Britain was often far more diverse in the types of artist and type of art it produced. Consequently the extreme demands for artistic freedom that fired up continental Europe never really caught on in Britain, not because the British were too conservative, but because the artists of Britain already had pretty much *carte blanche* to do as they pleased. For the truth of this statement compare the diversity seen in the British artists Blake, Cox and Gainsborough with any of their contemporaries in France. This is important because it shows how a very narrow definition of the aesthetic framework, whether at the hands of the Ecole des Beaux-Arts in France, the bourgeoisie of Wilhelmian Germany, or, in the twentieth century, the brutality of the fascist and communist dictatorships of continental Europe, provoked an equally strong rejection of all frameworks. To define a framework for art came to be seen as fascistic, communistic or bourgeois, and the radical dissenting artist became anyone who had no defined framework. I simplify the case, but the result was that if someone said it was art, it was art because anything else was seen as an assault on the freedom of the artist. Unfortunately it gave the artist freedom to spout nonsense in the name of art, and the tragedy of that was that it led to a profound misunderstanding of the nature of the aesthetic framework. The narrow frameworks for art defined by the French Academy, or the Wilhelmian bourgeoisie, or by Hitler or Stalin were not aesthetic frameworks at all. They were moral and

political preferences that had little or nothing to do with art.

<p style="text-align:center">* * *</p>

Let me tell you another story.

Once upon a time there was a village in the desert, and in that village lived a woman with her son. Every morning the woman would go out with her son to fetch a pale of water from the well, and together they would carry the heavy bucket back to the house. Everyone in the village did the same, it was part of life.

One day the woman thought to herself, my son is old enough now to do this on his own, so she handed him the bucket and told him to go to the well and bring back some water. The woman watched her son walk down the village street, bucket in hand, until he had rounded the corner, and when he had disappeared from sight she went back into the house to prepare the food for their daily meal. He was away a long time, but after a while the woman saw her son coming back, carrying the heavy bucket with both hands. As she watched him she felt a little guilty that he had to carry it on his own.

When he reached the house the woman's son put the bucket on the table, exhausted by the effort. 'There's a good boy', she said to him as she started pouring the water over the food. But as she poured no water came from the bucket. Instead, all that flowed was dry sand and stones. Confused, she looked in the bucket and saw that there was no water in it at all, only rubble from the dry earth. She looked at her son, and then the bucket and then her son again, and asked, 'I wanted water, why have you brought a bucket of stones and sand?'

'I went to the well,' said her son, but I could not draw any water. Only this barren earth.'

It must be a bad year for water thought the woman, so the next day she sent her son out again, this time to a different well, further away from the village, but always guaranteed to have

water. Her son was away for a very long time, and so the woman prepared a special meal to reward him for his hard work. After a while she again saw him struggling down the street, and again she thought that perhaps she should have gone with him to carry such a heavy load. This time she went to meet him in the street, and took the bucket from his hand, but again when she looked inside there was no water, only dry sand and stones. 'Why have you brought another bucket full of sand and stones?' she asked her son. 'Don't you know that we have no water left to drink or cook or wash?'

'I went to the well,' said her son, but I could not draw any water. Only this barren earth.'

The next morning the woman spoke to her neighbours. 'Where did you get your water?' she asked them. 'All the wells are dry.' But when she said this, her neighbours just laughed. 'The wells are not dry,' they said. 'There is more water than ever before.' So the woman sent out her son for a third time to the well, but when he had left she disguised herself and followed him to see why he never brought home water, only dry sand and stones. She saw him walk through the village, and followed him through the fields and along the path to the well. At the well there was a huge crowd of people all drawing as much water as they wanted. In fact, the water flowed more like a mountain spring rather than a desert well. Then she saw her son walk right past the well and into the dry desert. There he put the bucket on the ground and began scooping up handfuls of dry sand and stones. My son is mad, the woman thought. She saw him fill the bucket with dry earth and struggle to lift it, and as he did so she ran up to him and asked, 'My dear, my love, are you unwell? There is so much water in the well, but you fill our bucket with sand and stones?'

'I know there is water in the well,' said her son, 'but I do not want to use it. I do not like being forced to draw water from the well.'

I like this story because it reminds me of something the English

philosopher T.E. Hulme once said that always makes me smile. Hulme divided humanity into two types. There were romantics and there were classicists. 'The difference between a romantic and a classicist,' Hulme said, 'is their attitude to human nature. To the romantic human nature is like a well from which can be drawn infinite possibilities. To the classicist human nature is like a bucket, with such finite possibility that it is remarkable that anything good can be got from anyone'.[5] Hulme, who died on the battlefields of the Great War, defined himself as a classicist, but art cannot be in Hulme's definition of the word, 'classical'. Art is always romantic, not in some fey whimsical way, but through the necessity that the artist believes in the infinite possibility of humanity and the continuing definition and redefinition of human existence. Artists may be forced to go to the well, but it is a well of infinite possibilities and not a bucket that traps us. Indeed, that well is the only framework that allows art to exist in the desert.

Part 3: Communion

One of the biggest problems we face in art is that our language is corrupted. I have already had to abandon the use of the phrase 'art framework', even though 'art' it is one of our words, for fear of being side tracked into a futile and facile debate on the historical origins of the word 'art'. So I use instead the word 'aesthetic', and the phrase 'aesthetic framework', but this too has its problems. Few people who even use the word aesthetics have a clue as to what it means. Sometimes in lectures I will ask audiences to define the word aesthetics for me, and phrases like 'beauty', 'taste' and 'formalism' all come up as definitions. At least the recent renaming of beauty salons as 'aestheticians' seems to have the good humour of an honest theft, and was no doubt necessary to help differentiate such places from back street massage parlours. Most other uses of the word are, however, creepily dishonest.

When we use words like 'discussion', 'question' and 'answer' there are bigger problems. With such words we are importing into the aesthetic framework the language of other frameworks. Much of the language we use to discuss art today has come from the immaterial world of literary theory, with all the incorporeality that implies. Indeed, it is difficult to think of a set of ideas less like the physicality of art than the unphysical world of literature, so it has of course been imported wholesale into the discussion of art. Use of this foreign language can at best approximate what I mean when I use words like 'discussion' or 'question', but the discussion and questioning I am talking about is within the framework of visual art and so can never be an exact match. It is a bit like trying to speak English when you only know Japanese words. Ideally we should have our own art-words, although the importation of words and phrases from other frameworks into the framework of aesthetics is not necessarily a problem as long as we are aware of the limitations of such imports. If we speak of the

'language' of, say, sculpture we do not mean that visual art is a semiotic language based on signs and signifiers. Only a grand stupidity could conflate the borrowing of terminology from other frameworks with the nature of the aesthetic framework itself. Unfortunately, in the last few decades we have seen a great deal of time and energy spent on such grand stupidities, and this has resulted in the misunderstanding of the nature of visual art itself. Admittedly, this is not a new phenomenon. In the nineteenth century an equally futile attempt was made to persuade visual artists that they were really musicians who happened to use paint. Still today we talk of the rhythm of a painting, which is a legacy of that earlier fallacy. Even so, there is something particularly disagreeable in being told by people who seem to know very little about the physical nature of art that because we use terms like 'the language of art' then art must be the same as a spoken or written language –that is, it must be semiotically-based. We are supposed to accept that if we say the word 'tree', or write the word 'tree', or draw a tree we are effectively doing the same thing each time, namely creating signifiers of 'treeness'. Like many people in art schools, I was taught precisely to do this at university, and to my shame I even made my students do it in the past. It is an easy teaching tool. As a student I remember spending many futile hours talking about Roland Barthes and reading the signifiers of 'Italian-icity' in an advert for Panzani pasta sauces.[6] The joy continued when we extended this theory to art and discussed ideas such as 'van Gogh-icity', 'art-icity' and 'painting-icity', each time looking for the signifiers of van Goghness, artness and paintingness in what we were looking at. And how I remember blushing deep with shame when I was told not to be such a fool when I dared to suggest that this was surely just a form of symbolism, looking in visual images for one thing to mean something else. To be sure, I thought it was more advanced than saying the figure in yellow in Leonardo's *Last Supper* is Judas Iscariot because in Mediaeval and Renaissance symbolism Judas was always shown dressed in yellow, but the

principle seemed the same to me. In fact to this day I still am baffled as to why I received such a forceful dressing-down and why signs and signifiers are not simply recognised as a version of symbolism. Perhaps I had dared to look under the table in our séance, and saw the clairvoyant who was teaching us pull on a hidden lever to make the windows rattle and the lampshade swing. Perhaps that threatened to reveal that this latest theory was not so revolutionary at all. Instead it was a throwback to nineteenth-century literary symbolism, and as such was an alien import into the aesthetic framework, with no real place in the discussion of art at all.

Thankfully there was another tradition even at that university that was far more convivial. It was in its last days and on life support, but it was still there, and it allowed the questioning to continue. The framework of art may have been polluted, but it was still possible to see what concepts were irrelevant to any artist making a work of art, and any viewer looking at that work. It was still possible to realise that these two, the artist and the viewer, coexist in a far simpler but more profound framework than a symbolist one, in which the only significant question is over the veracity or believability of the artist's response to existence. *Can we believe what the artist is showing us?*, or perhaps *Can we suspend our disbelief at what the artist is showing us?* This is not a matter of signs and signifiers, gathered from different cultural sources, with meanings both specific and (with a wonderful sleight of hand by the clairvoyant) *en abyme*. It is indicative of something far more basic and primal. It concerns something far more tactile and even visceral. It is something present in the most intimate of questions, *If I touch you do you feel me?*, a question we have as humans to ask again and again for our own mental and physical sense of well-being.[7] This is an aesthetic framework because the word aesthetic, comes from *aisthesis*, meaning to touch or feel with the senses. Aesthetics does not mean beauty, or taste, or formalism. It does not mean a beauty parlour. It means to see and to hear and to touch and to taste and to smell. It is to breath, to bite, to

grab, to hold hands, to kiss, to embrace, to fuck and be fucked. Aesthetics is our experience as sensory human beings of embodiment. In art, therefore, there is nothing fey about the aesthetic framework. It is corporeal and visceral, and it is at the root of our being. It is also deeply romantic in that it is through these sensory mechanisms that we engage with existence, and, through our attempts to share that engagement, that we are in social communion with each other.

Part 4: Liberty or Death

We live in a time when more things are done in the name of art than at any previous point in human history. And yet at no other time in human history has so little art been produced. It is now possible to visit some of the largest and most famous galleries and art museums in the world and not see a single work of art; and despite more people graduating with university qualifications in art than ever before, there are now fewer artists than ever before. The explanation for this is simple. Whatever it is that is shown in these museums, and whatever the majority of these people called artists do, whether it is relevant, irrelevant, good or bad, it is simply not art. It is non-art. Make no mistake, I do not say it is non-art because I do not like it. That would be subjective and open to irrational prejudice. On the contrary, I say it is non-art for objective reasons, namely that it does not operate within the aesthetic framework that is necessary for it to be art. Indeed, it is not necessarily logical to say that because one likes art one must dislike non-art. The two are different things, and to express a preference for one over the other would be as illogical as saying *I don't like tables, I prefer cakes*. I might prefer cakes to tables, but equally I might like both as separate things.

Strangely enough I suspect the more intelligent practitioners of non-art would agree with me that non-art does not operate within an aesthetic framework, although they might disagree on whether that really means it should not be called art. The 'artistic' frameworks of non-art might be social, political, gender-based, issue-led or whatever, but in that 'whatever' I have to part company with non-artists as only the aesthetic framework is legitimately an artistic framework. Anything else is something else. This is to define the framework of art, although I would prefer to say we are *redefining* that framework, on the basis that it realigns the practice of art with a body of aesthetic ideas that is the true tradition of art. At the same time it correctly aligns non-art

practices, that are misnamed art, as being outside the tradition of aesthetic art. We separate the cake-makers from the carpenters. This realignment is long overdue. The redefinition of the framework of aesthetic art has never been more important because at this present time art that is rooted in the true aesthetic tradition is in danger of dying, not through a deliberate policy of iconoclasm −for such a policy would breed resistance− but through ignorance and neglect.

We can see this through a much shorter story this time, about a gardener. Once there was a gardener and in his garden he grew art. But the gardener was a soft-hearted fellow who would not pull up any plants in the garden even though they did not belong there. Over time his garden was choked by too many different kinds of plant, many of them weeds of no value, but many of them simply things that did not belong there. The result was that the art the gardener once grew slowly died out. Rather like this garden, our softness towards non-art growing in the garden of art is a kind of neglect. If we continue to allow the non-art to grow in our garden it will increasingly throttle art.

Another analogy is with the sport of rugby. Rugby in England was once a single game, allegedly begun on the fields of Rugby School. At first everyone played the same type of rugby, but in 1895 the game split into two types of rugby −rugby league and rugby union. Both are called rugby, both use an oval ball and to the untrained eye, they probably look pretty similar. But they are not the same. They have different rules, different governing bodies and the players are not permitted to switch from playing rugby league to rugby union or vice-versa.[8] The thing we call art is in the same position as rugby in 1895. So let us say aesthetic art is 'rugby league' and non-arts like conceptualism are 'rugby union'; the position now is that the two games of art-rugby are so different they need separation. They play by separate rules, so need separate governing bodies −an arts council for aesthetic art and a separate non-arts council for non-art. Galleries are needed for aesthetic art, and separate non-art galleries for non-art.

Magazines, schools and biennials for aesthetic art need dividing from magazines, schools and biennials for non-art. As with rugby, however, there is a need to make everyone aware of this difference, so we stop calling it all art, because it is not all art. Some of it is aesthetic art and some of it is non-art, or conceptualism, or concept-illustration. It is up to non-artists what they call themselves, but because what they do is not art it should not be called art. By trying to play these games of two rugbies on the same field, however, we are in a state of utter confusion and despair.

I am well-aware some people will accuse me of wanting to limit their freedom. Indeed, I have been asked why should the things I call non-art not be allowed to grow and flourish in the garden of art if it wants to? My answer is simple. Non-art can grow and flourish, but it is time to stop pretending it is part of an aesthetic tradition of art that encompasses at least 100,000 years of people making visual aesthetic statements. It is time to stop pretending it is art. It is something else, which, *I state again,* might be interesting, important and even very good, but it is outside the framework of art. It is wrong to call it art because it is dishonest to call it art. It is a lie and therefore a question of morality. In the end it is carpentry not cake-making, rugby union not rugby league, non-art not art.

It is also worth mentioning that freedom is not the same as the right to do anything. Art has had many false friends, who have preached absolute freedom without acknowledging that the only absolute freedom is death. The type of freedom that came from Duchamp, Judd, Kosuth, Ayer, and all when they said anything can be art, was very like a form of nihilism in the way it permitted everything but denied the validity of existence to anything and anyone. It was the death of art because everything was free to be art, and therefore everything was equally not art. Judd said that *If someone says it's art, it's art,* but the inevitable corollary of this is that *If someone says it's not art, it's not art.* In such circumstances the very word art becomes meaningless, which is probably why so

much of human activity is now able to fall under it as a title. To be free to say anything is art is to be forbidden from asking *what is art?*, and that is not freedom.

Perhaps I should point out that I write here as someone who defines himself politically as an anarchist, so as an anarchist let me state that I do not believe freedom is in itself a political goal. It is a rousing slogan, but in reality freedom can only be a mechanism through which the frameworks by which we explore and define our existence can be liberated from vested interests. The thing we call art today has many vested interests, often with a great deal of money and power. Those interests will not give up misusing the term art easily, as it affords them a sense of authority and kudos rooted in the history of art, even though that history of art has nothing in common with anything they say, do or promote. As a consequence they will mislead more and more generations of would-be young artists into pursuing activities that are outside the framework of art. Perversely, they will do all this in the name of art. This is an intellectual enslavement to a mainstream culture in which state art galleries, and multimillionaires, and professors in university art faculties and the poor little rich kids who flock to the next *biennale*, or Documenta, or Manifesta, can present themselves as the radical avant-garde of art.

When we talk of freedom, the artist is often held up as an exemplar. The bohemian artist in their garret, rejecting and rejected by society, is a cliché, but also a potent image. Yet it is difficult to imagine a more damaging image at this moment in time. There is no doubt artists have long had the freedom to question our experience of existence. Indeed, this questioning is part of the aesthetic response to our embodied existence. When I ask *Am I in communion with others, or am I alone?*, or when I wonder *Is it true?*, I am exercising my freedom to think and feel, but such freedom does not liberate anyone from the framework in which they can ask such questions. Freedom does not liberate the physicist from the framework of physics, or free the theologian from religion. If freedom is to mean anything it is only that it

liberates us from enslavement to vested interests, saving the physicist from turning her discoveries into nuclear bombs or theologians from the preachers of hate. Only in art, it seems, where a carpenter is free to call a table a cake and still be taken seriously, does freedom without limit seem to enslave us ever more to ignorant vested interests. It is a lesson that should be well-learned by the would-be artist working today; true freedom in art does not mean the artist can avoid drawing water from the same source that once fed the likes of Michelangelo, Gentilleschi, Turner and Hepworth. If it did, the carpenter could bake a table, we could drink desert sand, and conceptualism would be art.

Part 5: For Your Eyes Only

Recently I was a little taken aback by the comments of two old friends of mine. Independently, but within a couple of weeks of each other, one suggested that I am over sensitive to setbacks and criticism, and the other that I am too self-deprecating. Both comments rang true, and it is also true that when it comes to art criticism it has taken me a very long time to have the confidence to express an opinion that I believe is right. In the past I have given opinions on art, of course, but these have almost always been accompanied by a self-destructive sense of doubt, partly in the validity of my judgement, but more especially in my right to give an opinion at all. This has been the case even when I have seemed to bluster with arrogance. Lying in bed, awake in the witching hours, if the question ever entered my head, 'Who do you think you are?', my own answer was always, 'I am nothing'. Unfortunately this was a question that often entered my head.

Also recently my father started sorting out some old family photographs. These had been kept in a couple of old biscuit tins at the back of a wardrobe. There were a lot of them, but I think our hoard was quite typical. There were plenty of black and white and faded colour images of smiling aunts or uncles on doorsteps, most looking like a younger version of themselves, but some unrecognisably thin, or playful, or simply very young. Often dressed in cheap suits or miniskirts, every member of my family seems to have been blessed to wear National Heath Service glasses at some point, and in the photographs they often appear holding either myself or one of my siblings as a baby.

There was another large crop of fooling-around pictures from when my brother, Paul, was given a cheap camera one Christmas. Amongst these there was an inexplicably large number of images of a red formica-top table that used to live in the yard. There was nothing on the table and no one sat around it. It was just a series of photographs of a table taken again and again, like

a glamour model shot from different angles. But I do not imagine my brother meant any political comment by this.

There was also one of the nicest sets of photographs showing a rare scene of my brothers, sister and myself having a snowball fight in the days when it did snow.

And finally there were the less classifiable pictures —a sprinkling of tiny tattered black and white photographs of ancient relatives standing in places we did not know or could not remember; and the special occasion photographs, such as formal school portraits, taken every year in front of a badly painted sky by a local photographer who kept trying to make me smile even though I thought I was smiling. There were also images of one or more of us dressed up to take part in a carnival float or school nativity play. One of these pictures was quite startling. Taken on a school carnival float decorated for the Queen's Silver Jubilee in 1977, it showed a boy, aged six or seven. He was recognisable as myself, not only in the way he looked, but because of the painful shyness one could see in his face. It was a picture of someone almost me in body, and definitely me in mind.

The phrase 'painfully shy' is not hyperbole or metaphor. Shyness really does hurt, and as I moved into being a teenager my shyness spawned other problems that left me, at times, almost dysfunctional. School was difficult, especially as it was a Secondary Modern School with a particularly poor reputation. Of course a lot of people go through similar things, and a lot of people go through much worse, but my aim here is not to claim uniqueness in any of this —quite the contrary. I am probably describing the typical English experience of childhood and adolescence, despite my Greek origins, but the result of it was not some endearing Hugh Grant-like shyness, but the symptoms of a broader ailment, more like a physical illness. In my case it was an illness that sometimes made me very sick indeed. Personal relations were often difficult and sometimes I could not leave my room. I stopped eating, became very gaunt and deeply unhappy. Even so, this is a minor tale, and although it has a bearing on

how I have come to understand art, which is the only reason it is being brought up now, the full details are mine and have significance to none but myself.

It took a long time for me to get over this 'illness', at least to the degree that I could function in a human and humane way again. The most important turning point, I think, was a brief stay on the mental health ward at St James's Hospital in Leeds. Reading that now, it sounds highly melodramatic, but in some ways it was rather mundane. I was referred there by my doctor for reasons that are still not clear to me. I guess he saw something wrong. Although some of the memories are a bit hazy now, I do remember sitting in a dingy lounge on the ward, playing Ska songs on an old record player with another patient, a young man who kept asking me why I was there. All I could say was, 'I don't know, my doctor sent me'. The young man's advice was to get out as quickly as possible.

Obviously I was not a danger to anyone else, or even myself, and I had travelled to the hospital on my own, by bus, which is why I say it all reads more dramatically than it really felt, even at the time. Also, my hospital stay was short, 48 hours in all, until a friend, Ben Read, came to rescue me. In a frying pan to fire moment I was packed off to Cyprus where I almost accidentally married a girl I barely knew, but that is another story. The point here is about my hospital stay. It was an important moment as it was probably the first time I had ever experienced some distance on my life. By that I mean a psychological distance, rather than a physical one, although it was, in a sense, physical too. When you are in hospital, for whatever reason, the rest of the world does seem strangely distant. And so the sensations that had, up until that point, always been too close and churning and overwhelming were pushed back. This distancing was the best treatment I received. I only spoke to a doctor twice whilst there —once when I was admitted, and once when I insisted, against his advice, on discharging myself. The ward was not a particularly pleasant place, so the advice from the young man, to get out as quickly as

I could, was sound. And yet that ward also acted like a momentary refuge for me in a time of need. In the true sense of the word, it was an asylum from ordinary life. In my case it was like an inoculation from a disease, and once I had experienced it I was able to maintain the distance, and even extend it over time, allowing me to become increasingly less dysfunctional. So, although my friends might still say I take things too much to heart, and dwell on perceived slights almost indefinitely, and even carry profound doubts about my right to speak up and be taken seriously, I have known me when I was much worse. A brief time on the Roundhay Wing at St James's Hospital created a brief space between me and an unbearable moment on which I will not dwell, and in doing so it saved me from that unbearable moment.

Perhaps all of this explains why I am attracted to a theory which suggests that art functions in much the same way for society as a couple of nights in a mental health ward worked for me. Perhaps I should say I am attracted to a theory that suggests art is a mental asylum for society. One of the most interesting theorists in this area is the psychotherapist Wilfred Bion who saw our dreams as a kind of asylum in which we take refuge and gain distance from the assaults on our mental health which we each face every day of our lives. Bion called this process the Alpha Function.[9] As experiments and tragic cases have shown, those who fail to sleep fail to dream, and so find no distancing asylum from the chaos of life. The result is that such people go profoundly mad and can eventually die. With Bion's theory it is possible to suggest that the purpose of the artist in society is very similar.[10] The artist dreams for society. I admit this is an astonishing suggestion that places the artist at the heart of the well-being of society. From this theory we can speculate that a society that fails 'to art' is rather like an individual who fails to dream. Such a society will find no asylum from the psychological chaos that assails it every day, and will fail to find a safe space in which to resolve that chaos into something manageable, or at least into something bearable. That society can then be seen as irredeemably

mad, and it will surely die.

If we move directly into fine art practice it is around this idea that I would suggest a distinction is drawn between art that fulfils the Alpha Function and non-art that does not. That line of distinction falls neatly between aesthetic art on one side and the non-arts on the other. An aesthetic artist such as Francis Bacon might us show us the horror of certain aspects of life, but he does so within an aesthetic framework that creates sufficient psychological distance that the horror becomes bearable to us. It becomes faceable, even though it might remain difficult. Tracey Emin's *My Bed* (1998), on the other hand, fails as art for the simple reason it does not create any distance between Emin's initial experience and the object on display in the gallery. The object displayed as art is not an object of aesthetic distance, it is a replaying of the event again and again. The thing we call aesthetic distance in art is a psychological distance, and without it Emin's display of an unmade bed, crumpled sheets, dirty underwear and an assorted collection of vodka bottles, slippers, cigarette boxes, condoms and pill packets, is too close to Emin to be considered a work of art. It fails to transcend the reality that caused the pain in the first place, and remains nothing more than an assorted collection of vodka bottles, slippers, cigarette boxes, condoms and pill packets.

But the work also fails to gain resonance with others, and so people turn away, either out of lack of interest in the personality of Emin, or out of disgust, both of which are familiar responses to Emin's work. It is important to recognise that this is not a moral response, in the ordinary sense of the word, it is a psychological reaction to the failure of the artist to achieve aesthetic distancing in their work. Consequently the disapproval of the work is involuntary. That is to say, it is not possible to face Emin's work without a sense of disgust, even if you want to, because it is too much about a particular person and that person has left no aesthetic space for anyone else to inhabit. The viewer is, psychologically, crowded-out of the work. This is similar to a

parent going into their teenage son's bedroom and finding themselves repulsed by the mess they find there. Yet the teenager who made that mess has no negative reaction to it. The difference between the parent and the teenager is that the mess assaults the parent, leaving them no space of their own to occupy, whilst to the unkempt teenager there is no problem because it is all their space. Being crowded-out is psychologically disturbing, whether the thing that crowds one out is a physical space, like the teenager's bedroom, or a psychological space, like an art work we are supposed to empathise with.

The discussion of aesthetic distancing has its longest history in poetics, and many people will be familiar with the statement, made by Coleridge and Wordsworth in the preface to the *Lyrical Ballads*, that 'all good poetry is the spontaneous overflow of powerful feelings.' Yet, few who cite this justification for emotive art (or what supporters of Emin call 'Confessional Art') ever seem to get much further than Coleridge and Wordworth's initial statement. If they did they would discover that the 'overflow of powerful feelings' was seen by them as a two stage process, with the second stage being when the poet thinks 'long and deeply' about those emotions, rendering them into poetry in the process.[11] The feelings themselves were not, for Coleridge or Wordsworth, art, they were merely the honest source, or motivating impulse, from which art might be fabricated. Discussing this, Herbert Read claimed in 1953 that we can actually see the process of aesthetic distancing in action by looking at the evolution of Coleridge's poem *Dejection*, which deals with the raw subject of the poet's feeling of being trapped in a deeply unhappy marriage whilst in love with someone else. The original version of the poem, Read wrote, was over twice the length of the published version, and in making his changes to it Coleridge undoubtedly lost 'something we might call emotional integrity'.[12] In other words, the original emotional impulse was compromised by the process of thinking long and deep about it. But an emotional impulse, no matter how strongly felt, is not a work of art. If it was then every widow that weeps

or child who laughs would be hailed as the next Shakespeare and Michelangelo. The function of the artist, as demonstrated by Coleridge in turning the emotionally-direct power of his original impulse into the beautiful work of art that is the published poem *Dejection*, is to distance the art work from the original impulse sufficiently far to make it bearable, and give the reader space to inhabit the poem, but not so far that it loses all honesty and passion. This is a necessary balance, and the tension between these two positions is fundamental to understanding the difference between art and life.

As Bion's work suggests, as a function art reconciles society not only to the personal and emotional turmoils its members experience, but to those that are physical, sensory and sensual. We exist in a world where nothing is stable, and all things are in a state of flux. That flux will always disturb us. The wonder of reality is that it is never static, and although today it might be sunny and calm, tomorrow it might storm and rain. This brings to mind something that happened to me yesterday. I was standing on the platform at Alexandra Palace railway station in north London and a non-stop high-speed train sped by. This was a wonder in itself, astonishing in its power and speed. Then another went by; and another; and another; and another; and another; and another. Because Alexandra Palace is a local stop on a high-speed mainline these trains only ever sped by. They never stopped. As another went by, and another, my feeling of astonishment and wonder was replaced by discomfort, and then anger, or rather angst –that is by an overwhelming desire for the surge of noise and power –the flux– to stop. I had a need to distance myself from it. In our own natures too, and those of our fellow human beings, we are also in constant flux, and our moods will swing, and we all face the inexorable process of growing old. At some level these too provoke an overwhelming desire to escape from the immediate impact of the flux. It is all embodied in that old musical title, *Stop the world, I want to get off.*

From Coleridge and Wordsworth's description of thinking long

and deeply about the original emotional impulse, the process of distancing can seem like a highly intellectual or cerebral activity. But this is not necessarily the case. Although poetics offers useful parallels to 'kalitecnics', art is essentially a material activity and in that materialism lies one of its most significant distancing process. The sensation or emotion or experience that I feel is a part of me. By translating, as Henry Moore called it, the emotion, sensation or experience into a material object it ceases to be part of me and is, *ipso facto,* distanced. It is this defining feature of art, which differentiates it from all other human activity, that lay at the heart of John Ruskin's well-known advice to art students that they should:

Go to nature in all singleness of heart, and walk with her laboriously and trustingly, having no other thought but how to best penetrate her meaning and instruction, and remember the instruction; rejecting nothing, selecting nothing and scorning nothing.

Although this is sometimes misinterpreted as a manifesto for realism, it is in fact a manifesto for artistic materialism, with Ruskin advising art students to engage directly, materially and sensually with the physical world, before showing us 'what their heads are made of.'[13] Of course, Emin's *My Bed* is a material object too, but it is an object the elements of which fail to achieve any distance from their own natures because they are simply bits of our world presented as themselves in a gallery. There is no process of transformation. Emin can say *My Bed* is my bed, and as such it can have only any appeal to people who are not Emin if they have an interest in Emin's personality. The transformative process that takes a particular bed with a particular association for a particular person and turns it into a bed that has resonance with other people does not appear to have happened, and *My Bed* remains no more than Emin's bed.

This idea of art being an act of transformation often

flummoxes people even within the art world, but it is explained nicely curtesy of the non-artist Martin Creed. In his piece *Work No. 850* Creed arranged for a series of athletes to take it in turn to run around sculpture court at Tate Britain in London. This, we were told, allowed those athletes to experience the haptic sensation of moving through the gallery. But what this demonstrated was simply the difference between initial experience and art. In *Work No. 850* there was no attempt to transform the athletes' experience, to distance it, so that it could have resonance for other visitors to the Tate. All they saw was people running up and down the gallery, and the thing was untransformed, remaining no more than itself. The equivalent in more historic forms of art would be if Constable had decided to stop painting landscapes –that is if he had decided to stop trying to objectify his experience of the landscape through the materiality of paint– and just said 'Look out of the window and you can see a landscape'. A Constable painting is, however, a transformed material object that is neither simply paint nor canvas nor landscape; it is the physical manifestation of one person's experience of the flux of life, but unlike Emin's *My Bed* or Creed's *Work No. 850*, it is distanced enough from Constable to allow it to resonate with other people. Aesthetic distance is opened up between Constable and his experience of the landscape, and the resulting artwork is universalised. Similarly, its static materiality means the flux is made still for a moment, providing a moment of longed-for stasis, or, to put it another way, an asylum. The world is stopped, and for a brief moment we really can get off.

The paintings of Bacon are a particularly good example of the process of distancing in action, primarily because they are rooted in highly personal and often extreme experiences. In a painting called *Triptych May-June 1973*, Bacon's motivating force was the death of his lover George Dyer, who had committed suicide in 1971. In the three stark canvases we are shown Dyer vomiting in a sink, stumbling across a room and then dying whilst on the toilet. At first sight it is difficult to imagine a more raw or

unbearable subject for art, and yet we can wander around the National Gallery in London and see hundreds of paintings, going back centuries, showing people being crucified, beheaded or skinned alive. It might sound cruel to say this, but, like those images in the National Gallery, the death of Dyer is made bearable to watch, and therefore bearable to face, by being distanced from the artist's direct and raw emotion. In this case the aesthetic distancing is made partly through an appeal to the history of art, with Bacon adopting the triptych form of historic religious painting, and drawing on modernist art traditions in his handling of paint and spatial construction. The result is that rather than asking us to wallow in one person's unbearably direct and personal human suffering, Bacon creates an aesthetic, or psychological, distance between himself and the subject. The space that is opened up by that distancing is inhabitable by the viewer, and in doing this Bacon reiterates the lesson learned from Coleridge about one of the fundamental purposes of art: how we can face unbearable experiences and still survive.

There is a danger here that we might think art is only invoked in the face of things that are grim, to make unpleasant things bearable, but that is not necessarily the case. Sometimes it is also difficult to face, or gain distance on, positive emotions and experiences. When I left school I went to study at Canterbury Technical College. In one of my classes there was a girl, one of the most beautiful girls I have ever met. As Bion might have said, she overwhelmed me, but I could get no distance on my feelings at that time, so for months I could barely say a word to her. One day I was in the city centre sheltering from a heavy downpour in the porch of the Beaney Institute. The rain came down and the street emptied of everyone, except those brave enough to put their faith in an umbrella during a torrential summer storm. Not many did, but I recognised one of them. Walking up the street, it was the girl, and in the wonderful witless moment that I saw her I just rushed out, grabbed her arm and huddled under her umbrella. It was so like a movie scene it was almost comic, and her umbrella

was so small it barely sheltered her, let alone the two of us. But she did not seem to mind. I had forgot myself for a moment, as my damaged social self was overwhelmed by my intact embodied self. It was only a moment, followed by a walk in the rain, but it was lovely. Or at least it was lovely to me, and perhaps to me alone. Even at that moment I could not distance myself enough to think the girl might share the sense of wonder I felt at what I had done, or that she had seen my George Peppard moment corresponding with an Audrey Hepburn one from her. So the moment passed, and added up to little more than a sense of intense regret to add to my neurosis.

Yet, how should I convey my feelings from that extraordinary moment to you?

Given my poor state of mind at the time it went beyond extraordinary. So should I make you stand under an umbrella, and put my arm around you whilst studio technicians douse us with buckets of water? Shall I simply show you an umbrella –perhaps even *the* umbrella– and let you work out from the sight of that what happened to me, what I felt, what she felt? Shall I simply paint or photograph an image of a couple under an umbrella –would that convey my feelings? Tellingly, each of these suggestions does read like a dull and inadequate attempt by a conceptualist to signify this experience, but the truth is none of them will do. Each tries to either replicate or signify something that cannot be replicated or signified –my sense of self, my embodiment, in that place, at that time and with that girl.

Instead of imagining I can convey such experience directly, I might instead follow Coleridge, and Bacon, and even myself in the madhouse, and try to distance the experience from myself, not so much that it loses its essence, but enough to communicate that essence, by giving *you* space to enter *my* scene.

As an experience it needs to be transuded through an aesthetic filter, out of which it might, if we are skilful and lucky, emerge with some kind of universal resonance, some kind of space for a willing audience to inhabit. Of course it might not gain any

resonance, and so remain a simple memory to me; but that is the necessary risk of failure in art.

Part 6: The Enemy Within

Talking of Francis Bacon, a few weeks ago I was in a bar in Larnaca having a drink with an old friend from England, and some of the tutors and students from the local art school. My friend had just given a lecture on Bacon, which was very good, and well received, at least from what I could tell. It was particularly good because he did not approach Bacon as an academic art historian who might have been interested in the artist's biography or the social context of his work, but as someone interested in the fabric of the paintings. This was surprising as my friend is, in the eyes of most people, very much an art historian. Yet there he was talking about the formal qualities of the paintings, their psychological impact and what an artist or art student might actually learn by looking at the work of another artist.

It was a highly unusual approach, and in the bar we had a great discussion on whether looking at art in this way really is art history, or whether it should be called something else. Applied art history I suggested, making an analogy with the difference between pure mathematics and applied mathematics, but as my friend rightly said, the problem with that is that pure mathematics is often considered higher than applied mathematics, whereas applied art history would have to be thought higher than academic art history.

I don't know if this is unique to the art school in Larnaca, but despite the general bonhomie, I have noticed there often comes a moment after an art historical talk when things are not well. This is very specific to art historical talks, and does not seem to happen with artists' talks at the place. Usually after a few drinks, the art historical speaker will find themselves being harangued for the sins of others. I have experienced it myself, and I sometimes joke that it used to only happen to me in barbers' shops where the barber would invariably ask me what I do. 'I write on art,' I would say

only to find myself subjected to a tirade of abuse from the barber against Damien Hirst, or Tracey Emin, or whoever the tabloid newspapers were pillorying on that particular day. The barber near Farringdon underground station in London was always the worst as he still used a cut throat razor to shave your neck, usually right at the moment when Emin's name entered the fray. On those occasions I would invariably agree with him, but that was rarely enough to pacify the heartfelt anger from a 'man-in-the-street' for what they saw was passing for art. So I felt for my friend and colleague, who had given a great talk, aimed at artists and art students, on a very good artist, to universal acclaim, as he found himself lambasted for the sins of the art world. Like my experience in the barbershop, my friend found himself identified as someone involved in the misguided art world, and with no other outlet for their anger towards that world, the tutors subjected him to a verbal ear-bashing. No doubt they felt better for getting it all off their chests, but my friend was a little taken aback. He has always been a friend to art and a friend to artists, so it was a mystery to him how he had caused such sudden offence.

Talking about this the next day over a coffee in the pretty village of Lefkara, said in Cyprus to be inhabited by the most niggardly people on the island, we agreed that because both of us are identified with the world of art history we often face the charge from artists that we 'know nothing about art'. It is an unpleasant and unforgivable form of abuse, but it goes with the territory. It is an attempt to assert one's authority without really having earned it, and is, I suppose like having hecklers at a comedy club: you have to learn to deal with it. If I feel charitable I tend to say it is not difficult to understand why there is this hostility to art historians amongst some artists, and why it spills out into abuse. In the 1970s art historians were at the vanguard of the forces that came to destroy the art school tradition of fine art, particularly in Britain, and they benefited from an increasingly dominant belief, in political, educational and, eventually, cultural circles that fine art practice was not on its own an intellectual

activity. This was a particular problem as the pressure grew to create bachelor degrees in fine art, and the universities started to take over the old art schools. The solution was to impose the study of academic art history on to fine art students, regardless of its relevance to any individual student's work. The imposition of art history gave fine art an academic fig leaf, but the downside was that any student who failed an art history course that had no practical application to their work also failed their fine art degree. It was a major shift that took art away from being a practical subject and turned it into an academic one. Had the principle of this new academic art been in place in previous centuries it would probably have consigned most of the greatest artists of the last five hundred years to oblivion. And if one cares to ask why have no great artists been born since the Second World War, it offers a possible answer.

But let us be very clear about this. I am not saying there is a problem with art's history being at the heart of art practice. It should go without saying (but needs saying still!) that the study of art's past is essential to any art student or art practitioner working now. Any painter who does not choose to go into galleries like the National Gallery in London when they have the opportunity, does not deserve the name of artist. Any sculptor who does not visit the Victoria and Albert museum, or its equivalent elsewhere in the world, is not an artist. And anyone who uses the justification for not doing these things that the National Gallery and V&A are full of old art is too stupid to be an artist.

But this is a digression. The point is, had an appropriate form of art's history been placed at the heart of the new fine art degree system back in the early 1970s, rather than the inappropriate form that was placed there, then all might have been well with art now. Unfortunately what was placed at the heart of that system was not the study of art's past, but an academic art history, in which art was seen not as a material artefact concerned with form, colour and space, but as a social illustration. Such art

history offered nothing that could have been of benefit to artists. In short, it was not art's history that was the problem, it was the increasingly self-important subject of academic art history, and by putting it at the heart of fine art, the educational experts who devised the template for fine art degrees might just as well have forced trainee brain surgeons to pass a course in French poetry before being allowed to pick up a scalpel. Some surgeons might well benefit from studying Mallarmé, and perhaps there is a tangental relationship between Rimbaud and medicine; but studying French poetry will not make a good surgeon a better surgeon. This is because poetry and surgery are different frameworks, and although both might tell us something about the nature of human existence, they do not tell us the same thing. So it is with fine art practice and academic art history.

As I have said, all artists and art students need to know, understand and learn from art's past, and they need to do so in a way that is very different from the need of any surgeon to know about French poetry. But learning from art's past is not the same as studying academic art history, and we can distinguish between the way an artist looks at and analyses a work by Rubens, Caravaggio or Zurbarán to the way an academic art historian contextualises a work by Rubens, Caravaggio or Zurbarán. Whilst one is interested in the nature of the art work as a material object, in which the formal properties of line, shape, colour and space are primary, the other is interested in the context of the work, what it tells us about the nature of society when it was made, or what it tells us about our society in the way it is displayed. There is very little connection between these two approaches and there is no genuine benefit in the fine artist or fine art student studying academic art history. That is where applied art history might prove useful, but as such a subject does not yet exist, it is academic art history that is taught. And as academic art history has grown in power vis-à-vis practical fine art, so the link between art history and fine art has become ever more tenuous. The result is the bizarre situation that art students are

now forced to study all kinds of mutant art histories, from cultural studies to contextual studies to visual studies, and in some places even media studies, none of which can help them improve their art.

The irony of this situation has been that by forcing art students to look at art in the way that academic art historians look at art, the art schools gave ammunition to the non-art conceptualists who shared a similar idea of art to the art historians. For both, the art work was a signification of a subject, concept or idea, waiting to be read by anyone with the semiotic skills to do so. It was this alliance of academia and conceptualism that destroyed the independent art school tradition, and which has almost destroyed the fine art tradition itself. No wonder fine artists rail at anyone identified as an art historian after a drink or two, regardless of the praise heaped on them earlier in the evening. In lucid moments these art tutors, and artists like them, would probably agree my friend was not the enemy after his lecture, and that he (and I) are part of the solution. But rather like an anti-Nazi German living in wartime Britain we know we are subject to suspicion and misunderstanding wherever we turn. If ever there was an aesthetic revolution in this country we would probably find ourselves interned as enemy aliens, and end up sharing a camp on the Isle of Man with the editorial board of *October*. But that is all too ghastly to contemplate.

My compassion for the attitude of some artists can only go so far, however, as the abuse experienced by my friend always seems to come from the most feeble individuals, in terms of both their practical and intellectual abilities. My friend's harassment in particular seemed designed to hide his accusers' inadequacies. Indeed, when I looked at one young woman going on at him I couldn't asking myself what had she ever done to move forward the cause of aesthetic art against the axis of non-art. I was not even sure she even understood what the real problem was, otherwise how could she presume it is enough for her simply to go into her studio every few days and withdraw wholly from public

life, without realising that it is precisely this kind of selfish privatisation of artistic life that has left the public sphere open for conceptualism to thrive. It is a failure of what Sartre called *engagé*, or engagement, which leads to a kind of self imposed marginalisation. I suppose you could call it a cult of victimhood that has taken over a section of the fine art world, with many of the same artists who bemoan their lack of success actually taking masochistic pleasure in being ignored. It is phenomenon called displacement, and the artists who rounded on my friend in Larnaca for the failings of the entire art world, after he had given a talk that was in itself a ameliorative to those failings, were displacing their own shame that they do nothing, or little, or comparatively little of any worth.

What seemed to shock my friend most of all, however, was the claim he could never understand art because he does not make art. Of course it is irrelevant whether someone talking on art is a maker of art or not. To say that only an artist can understand art is to restrict the audience for art rather dramatically, and it shows a terrible disdain for the people whom artists expect to show, view and buy their work. As an argument it is the ultimate in the privatisation of aesthetic art, and it fails to recognise that although artists should not be concerned with simple social symbolism or facile concept-illustration, they do have a responsibility to engage with society because that is the function of the artist in society. It is Sartre's *engagé* once again.

I saw a classic example of this recently when Mark Leckey won the 2008 Turner Prize at London's Tate Gallery. As Leckey stepped off the podium he was asked by a Channel Four news reporter what he thought of the criticism that this year's prize was not as good in previous years. Turning on the questioner Leckey pointed to the rarified elite and closed audience attending the ceremony and said, 'I make work for these people, not for the press or the people out there.' It was a nice example of someone claiming to be a socially-relevant artist actually denying the relevance of society. We out here were dismissed with the wave of

an imperious hand as irrelevant, whilst the only judgement Leckey seemed to value was that of his own clique as it sat in the Tate Gallery that evening. It was truly privatised art.

Yet the real danger with the type of hostility that emerged in the Larnaca bar that night is that a ridiculous anti-intellectualism takes root, in which the making of art is rendered into no more than a craft. All art has an intellectual element, and is never a spontaneous outpouring of emotion or some kind of innocent expression. Again, that is not the same as saying art is the illustration of ideas or concepts, but it is to recognise that thinking of art as a non-intellectual activity is an extreme error. It is the same error made by those politicians, educationalists and conceptualists when they sought to increase the academic content of fine art education by forcing students to study academic art history. In reality, when an artist or art student enters a gallery they make a series of intellectual choices. They choose one gallery and not another. They choose to look at some works of art and not others. They choose how to look at a work of art, whether passively or analytically. They might look at the colour values, the way the paint is applied, how the sculpture occupies its space, the quality of the surface, the nature of the composition, or any combination of these, and in doing so they make choices. They choose whether to sketch or make notes or to buy the catalogue, and in all of these choices they are engaging with art in an intellectual way. They do the same when it comes to a newspaper or magazine review of an exhibition, a book they might look at, or a conversation they might have about art over coffee, or in an Indian curry house, or even in a bar after a lecture.

Of course, some artists will do more of this than others, and their work will be richer for it. All things being equal, an artist who makes a choice not to visit the National Gallery when in London will always be an inferior artist to one who does make that visit. This is not because their technical skill will necessarily be any lesser, but because their base load of the experience of great historic art will be relatively diminished. There is an analogy in

this with something as unlikely as learning to drive a car. After one passes the driving test, many of the technical functions of driving come to seem automatic. One does not have to think to change gear, or turn the steering wheel, or use the breaks, one just does it. No one is going to claim the technical functions of driving are natural, but eventually they do come to seem natural. Even so, some people are more naturally good at driving than others, and so some people are more naturally good at art than others. But whether one is learning to drive or learning to make art, what improves the ability of both the gifted and the not so gifted is an adequate base load of knowledge and experience. In other words, the more lessons you have from an expert, the better driver or artist you will be. What this means specifically for art is that it is the choices an artist or art student makes to engage with the history or tradition of art that determines the quality and quantity of their base load knowledge of art. That knowledge informs an artist's practice whether they like it or not, or they are aware of it or not.

In a curious way this makes becoming an artist deceptively easy. The possession of some natural ability, a gift or genius, might help, but more important is the development of technical skill and a knowledge of art's past. These are the only things an art school can really teach, as no one can learn to be a genius, just as no one can ever teach someone else to have a good idea. The irony is that the destruction of the art schools, and the rise of university art departments, means that very few art graduates are being equipped with either technical skills or a base load knowledge of art. They are being equipped with irrelevant contextual information.

By talking about art in this way the aim is always to recognise the intellectual element of what is and always was an intellectual and practical activity. We do not necessarily promote a dry academic or conceptual practice when we talk about the intellectual aspect of art, but we do recognise there is no such thing as 'blind' artistic practice. Art is not a natural phenomenon like a tree, or a

rock, or the sky. Art is always the product of a human being interacting with the world. And while a human being is always a sensual, tactile and physical animal, he or she is also a mind, and it is a dangerous form of dualism that fails to recognise this. The art work is both the expression of a single human being's engagement with existence and a tentative definition as to the nature of that existence. It is in the second of these facts that communication with others, such as the wider non-art public, becomes possible and necessary, and that communication is not the sole preserve of the art practitioner.

As for our art historian guest, who I have had the pleasure of knowing a very long time, I have already asked him back to the college in Cyprus. He seems to know what he's talking about.

Part 7: Tentative Mathematics

When I was a first year student at university I used to go to all the public lectures I could. There were a lot of them, and I heard about astonishing things in science, history, philosophy, and much else besides, all well outside my nominal areas of study. Do students still do that? Do they still have an interest in more than themselves and their area of study? Do they care about knowing things, or just what they need to know to pass their course? To be honest, I was unusual even then, but by no means alone.

One of the lectures I attended was given by the great historian Hugh Trevor-Roper. He must have been well into his seventies by then, but he gave a good talk which revisited C.P. Snow's idea of the sciences and the humanities being two cultures that were disastrously separate. As always the talk was followed by questions, and I was keen to ask whether Snow had not been wrong in identifying the 'two cultures' as science and the humanities. Even in the early 1990s I thought there was a different set of diametrically opposed cultures operating in society. Unfortunately, the extreme protocols of hierarchy that still operated at Leeds University at that time meant a first year undergraduate like myself was not allowed to ask a question of a guest as distinguished as Trevor-Roper. That too was a salutary lesson.

But to return to my point. Despite the assumptions of Snow, I have never been convinced of the idea that the two mutually-antagonistic cultures in our society are science and the humanities. Perhaps it was more the case in 1959, when Snow claimed that such a divide was opening up, and certainly at that time no one could really have foreseen the emergence of a very different set of two cultures: the *serious* and the *slight*. I am also not sure those labels really do the division any justice, particularly in relation to the slight, as they fail to convey the astonishing aggressive power of all the slight, talentless and infantile forces that we see in art,

politics, society, education, literature, media and so on, as they try to overwhelm us. Perhaps we should say the divide is between the important and the infantile, but in doing so we need to recognise also that this is not simply a division, rather it is a battle and at the moment the infantile is winning.

From a personal point of view, I am serious about art because I believe art is serious. I do not sit po-faced in galleries –on the contrary when I am with people I know we are animated, jokey and engaged in what we see. We will joke even about serious works of art, but in doing so we never forget that art is a serious matter. That is why there is no place for irony in art. There is no doubt that anyone who does not think about art in this way should not be in the art world. Certainly Andy Wharhol didn't get it, which is why he never amounted to much as an artist.

As someone who is in the art world, I do not have a particular problem with either mathematics or science. I enjoy science programmes on the radio and television and even read popular science magazines, such as *New Scientist* and *Scientific American* on a regular basis. I do not expect everyone in the art world to do this, but it does seem to me that the failure to engage with other expressions of the human experience of existence, such as science, but also history, psychology, philosophy, literature, and so on, is a mistake. As I have made perfectly clear elsewhere in this book, this is not an excuse to pollute art with the frameworks that inform other disciplines, but there is a need to be engaged. Art is a distinct expression of the human experience of existence, and essential to it is the material, sensual and physical essence of art, which is embodied in the word aesthetics. But there are other expressions of the human experience. There are other frameworks, and for some of them material, sensual and physical essences are also important. Equally, for others, such materiality is not important. But whether they are sensual or physical or not we would be diminished if we diminished them.

For Ruskin none of this would have proven a problem. For him art was distinct, and in its own way unique, as a means to

establish the nature of human existence. Yet, science and other philosophical frameworks were not inferior or irrelevant. Ruskin contrasted aesthetics (*aisthesis*) with knowledge (*mathesis*), but not in a statement that made them mutually exclusive. He was not suggesting the divergence of two cultures, rather the totality of a single human culture. It was not, for him, a case of being an artist interested in *aisthesis* and not *mathesis*, or being a scientist interested in *mathesis* and not *aisthesis*. On the contrary, such a separation was unhealthy, both for society and the individual. Sometimes it can be easy to forget that in the art world, as though science and technology are so alien to art they are dangerous to the practice of art.

I used to think something similar about sport, but that was born of my incompetence at sport at school. I remember one year my secondary school thought it a good idea to hold a football tournament between the different classes. The matches were held every lunch time for a month. In my class there were twelve boys, so eleven of them were chosen for the team. I was the twelfth. One day one of the other boys came in with his arm in plaster, and so the class was forced to allow me to play. 'If you have to touch the ball, just kick it to someone else,' they said. So we started to play, and we started to lose. We always lost, so why this time it was my fault, I don't know. It was particularly galling to be blamed for every cock-up on the field when I am sure, even to this day, I was very good at football as a child. But after ten minutes of play, and a lot of shouting by my team mates, they decided to make a substitute. I was taken off and the boy with the broken arm brought on. Even with a disability, it seems, he was preferable to me.

I lost interest in all sport after that, and opted to join the swimming class once a week. This was great as it involved a coach ride into town, from which it was easy just to bunk off and slip into the ABC cinema. The result was that in my mind arty people like me were clearly no good at sport, had a duty to get out of sport and were generally hated by sporty people. Art and sport

were, I came to think, unbridgeably separate. And yet, many years later, when I was teaching in Scarborough, one of my colleagues, Jason Brooks, turned out to be a keen golfer. More than that, he turned out to be a talented golfer who had even won tournaments. When he first mentioned golf I remember saying something vaguely dismissive about sport. Immediately I had said it, I felt small and petty, and I still cringe at my comment even now. I do not like golf, and I still do not like sport generally, but in seeing art and sport as so separate, and making such a public point about it, all I did was expose a mean-minded streak in myself. Sorry Jason. But the same point strikes me with artists who dismiss science, and equally scientists who dismiss art. It smacks of petty-mindedness.

In all of this interest in other aspects of life there is one serious constraint, however, which is time. Art is such a big thing, it is doubtful can we have time to be equally interested in every other framework. To be part of art is to be obsessed by art, and unless there is that obsessive-compulsive engagement in art then art will never rise above the mêlée of our lives. No great artist ever faffed about.

The reason for mentioning all this, however, is a conversation I had with Clive Head in a cafe in Villiers Street, near London's Charing Cross station. Clive told me that mathematics is essential to art. His starting point was that art is concerned with the establishment of credible space. Earlier in the day we had agreed to use the term credible space, rather than believable space, as the latter implies space that looks like space in the everyday world, rather than the created space of a painting. Painted space, Clive argued, could be credible without being realistic, as in the case of Kandinsky, who created credible abstract space. The establishment of credible space is achieved, he suggested, through the mathematical relationships between the forms depicted in a painting. This can be seen easily in an early Renaissance painting, such as Masaccio's *Holy Trinity* in which the lines of perspective are generally so clear that it is relatively simple to see that a

mathematical process has been used to define where things are in relation to each other. Simply put, the things depicted grow or reduce in size according to a mathematical formula depending on how near or far they are meant to be from the viewer's fixed position when looking at the painting. When we say that art became more complex after the Renaissance what we are actually saying is that the mathematics governing the establishment of credible space in a painting became more complex. What makes Diego Velázquez's *Las Meninas* a more sophisticated painting than Masaccio's *Holy Trinity* is not its concept or subject matter but the differing mathematical frameworks that underpin the spatial construction of the two paintings. These mathematical frameworks govern the establishment of credible space in the paintings, and to put it baldly, the mathematical framework of the Velázquez is more complex than that used by Masaccio.

What this seems to suggest is a different set of mathematical frameworks exist between paintings and painters, some more complex, some less so. Again, if we transfer this back into the standard way in which we discuss painting, what we are saying here is that space in a painting has to be credible, that credibility is governed by the spatial relationships between the elements of the painting, and the spatial relationships are essentially mathematical.

The important thing to recognise in discussing this is that mathematical processes are not a hidebound set of pre-given rules; they are organic and creative. Talk to mathematicians (as opposed to school maths teachers) and they will say something very similar, and even admit that intuition, leaps of the imagination and the bending and breaking of seemingly fixed parameters are essential elements to it. Indeed, in higher mathematics one plus one does not always equal two, and as a consequence mathematics need not be seen as anti-creative or even anti-romantic, any more than the mathematics that governs the music of Beethoven, and which he used and manipulated to compose that music, is anti-creative or anti-romantic. In this we need to reject the hypocrisy in the contemporary art world which

recognises music to be an art of mathematics, whereas visual art is often seen as antithetical to mathematics. A useful starting point for understanding this is Patrick Heron, who wrote in 1953: 'What time is to the musical composer, space is to the painter.'[14] This was not intended as a poetic metaphor, it is indicative of a fundamental relationship not between music and visual art directly, as though painting the sound of music was ever a worthwhile exercise. It is indicative of a fundamental relationship between music and visual art indirectly in that both are underpinned by mathematics.

In seeking to establish credible space, therefore, the visual artist is seeking a mathematical answer to a spatial problem, in the same way that in seeking to establish rhythmic unity and harmony the musician is seeking a mathematical answer to a temporal problem. In painting this problem is a question of the relationships between the painted forms, which in turn governs how one form seems to occupy its own space on the picture plane. Similarly the direction of one line on a picture plane in relation to another line is also a mathematical problem, with the relative size, shape, angles and length of each seeking a mathematical solution. As Clive suggested, unlike the speculative mathematician the artist is in the fortunate position of always having the answer to their problem right from the start of their picture making, the answer always being 'the painting equals the establishment of credible space'. Sometimes this is true in mathematics too, with the answers known before the equations to arrive at them are worked out. For both art and mathematics too there are rules that govern how one can arrive at the answer, but there is often the need to create new rules to gain that answer. Again the creativity of mathematics is asserted here, not because it is a parallel subject to art, but because art is underpinned by mathematics.

Given this, it might be better to say there are frameworks to arrive at the answer, rather than rules, so that we acknowledge credible space in a painting is achieved not through predetermined formulae, but through a framework of possibilities. An artist

should say I aim to establish credible space, but this statement will always be followed by the great unknown: if I place a form on one part of the canvas how do I establish the space that it occupies as 'credible'? How will that credibility change if I want to place another form on another part of the canvas, and how can I work this out? With each new form the difficulty in establishing credible space becomes more complex, which is to say the mathematical formula becomes more complex.

I was asked by an art student with a scientific background whether this was not just a case of borrowing science to make art seem more intellectual, but the answer to that is that the idea of connecting aesthetics and mathematics does not originate in the art world. It comes from mathematicians. In particular one can cite Albert Einstein and Paul Dirac, with the latter in particular known for claiming that the truth of a mathematical theory is commensurate with its beauty, even to the point that a theory that more adequately fits empirical evidence was considered by Dirac less likely to be true if it lacked aesthetic beauty.[15] Professor Theo Kuipers of the University of Groningen has stated: 'Among scientists the intuition is that there is a strong bond between [truth and beauty]. Dirac is the classical representative of this intuition. Many other examples of natural scientists expressing this opinion could be given.'[16] Important current research in this area is also being undertaken by Dr James McAllister of the University of Leiden,[17] whilst at a grassroots level, the existence of the Maths-Art Group at the London Knowledge Lab —which seems attended by more science-based people with an interest in art than vice-versa— suggests a strong desire to explore the aesthetics of mathematics and other sciences amongst scientists. This raises the intriguing point that at this moment in cultural history, when art seems to have given up on the task of defining the twin pillars of truth and beauty, which has in turn resulted in the mainstream art world turning its back on aesthetics, science emerges as the new and seemingly growing apologist for aesthetic theory. A corollary of this is the realisation that the period of modernism, particularly

since the Second World War, during which we have seen technology, higher scientific theory, mathematics, political discourse and social organisation get ever more astonishing in their progress and complexity, has seen a cretination of visual art, and a corresponding celebration of stupidity. In recent years scientists have created the CERN Large Hadron Collider in Switzerland, Apple has created a computer almost as thin as a piece of paper, and doctors at the University of Modena can now cure certain forms of blindness. But in art we all flock to the Royal Academy in London to see Anish Kapoor fling lumps of red wax at the gallery walls. Again we face the serious and the slight and it is hard not to think it is not art that should look down on science but science that should look down on art, and art should be ashamed. Artists should be ashamed.

But to return to my point: it might be argued that if we acknowledge that the mathematical process of defining the illusion of space is in some artists instinctive, and seemingly second nature, then what is the point in emphasising that there is a mathematical process? After all, there is not emphasis placed on needing eyes to see to paint, it is taken as a given. My argument to this would rest on two factors. The first is that too much emphasis on natural intuition is a recipe for bad art, and the second that in recognising this as a mathematical process we gain an extremely powerful teaching tool to help young artists.

The first of these, that too much emphasis on intuition is a recipe for bad art, is not to say that intuitive processes cannot lead to good art. That would clearly be a very foolish assumption. The over-reliance on intuition does, however, turn the creation of art into something of a hit-or-miss affair. In the end it is little better than giving an infinite number of monkeys an infinite amount of time to produce the complete works of Shakespeare. Statistics tells us that they will do it eventually, but most of what they produce will be rubbish. In fact my analogy is a slur on monkeys as no primate other than humans would deliberately try to disengage themselves from mental reasoning when confronted

by complex problems.

After my discussion with Clive on this, I began to consider the idea of instinct and the production of art in relation to Coleridge. In particular, I began to think more about the process by which Coleridge produced the poem *Dejection*. For Coleridge, the initial motivating force for the poem was the despair he felt in his unhappy marriage and the hopeless love he felt for another woman. Such a motivating force (which is essentially Kandinsky's *Innerer Klang)* is necessary for art. In Coleridge's case it resulted in a torrent of words, truly a spontaneous outpouring of emotion. And yet that torrent was not the poem that Coleridge eventually published. It was not a work of art. Instead, what followed on from the initial manifestation of the motivating force was a long period of contemplation of what had been written, or we might say expressed. Personally, I had never really thought about what contemplation might mean in art practice, and I guess I imagined Coleridge sitting in his study, surrounded by books and a marble bust of Schelling, doing very little. I suppose I saw contemplation as a passive thing. Had the process of contemplation been passive, however, then the published version of Coleridge's poem could not have been produced out of it. It makes obvious sense that far from being passive, Coleridge had been actively editing the words that resulted from the motivating force, so that they were concentrated into the poem –the work of art– that was in the end published. That process of dynamic contemplation resulted in the wordage being reduced by about half, and a metrical structure of rhythm, rhyme and pattern being constructed. This process was clearly an intellectual one, but when we talk about rhythm, the patterns of rhyme, structure, meter and so on, we might just as well talk about a mathematical process as it is a mathematical structure that is being constructed. That mathematical structure is the space of the poem. None of this will come as a surprise, I think, to any musician, as the structure of music is well-established as being mathematical, and neither should it come as a surprise in poetry, which was born as the twin sister of music thousands of

years ago. Indeed, until very recently there was no real dividing line between music and poetry, with the result that it makes sense to recognise that the mathematical structures that underpin music also underpin poetry. I suspect, however, it will raise a few eyebrows to suggest that Coleridge was using mathematics to construct what is essentially a forlorn love poem. When we ask —as I failed to ask for many years— what was Coleridge doing during his time of contemplation, the answer is he was engaged in a kind of mathematics, and through that process he converted the raw motivating force of his emotions into communicable aesthetic art. Through the mathematical process space was opened up between Coleridge and those raw emotions, an aesthetic distance, and in that space the reader of his poem, his spectator, was able to find some room they could occupy. The space was, therefore, essential in allowing something extremely personal to become publicly acceptable, by which I do not mean acceptable in a moral sense, but acceptable in that it possessed credible space that could be occupied by someone other than the writer. It was universalised.

It is curious how an almost chance conversation can open up new insights into things one assumed were already understood. A long time ago I read an interview with the artist Terry Frost, I think in *Studio International* or *Art Forum*. In it Frost said his abstract paintings started with an event, such as a walk by the sea. From that Frost went back to his studio and started painting, using the experience of the event as his motivation. Then he said there followed a long period of contemplation. That word again. And again, as with my reading of Coleridge, I think I misunderstood it almost completely. I had never really bothered to think what Frost meant by contemplation, and I even remember teaching some of my own students that he just sat and thought about his work! That's what a misunderstanding of artistic contemplation does to you, and if Terry's delightful ghost was looking down on me during those lessons he must have been pissing himself with laughter. He would have wondered what the Hell is this idiot

saying about my work. It is clear that to understand both the processes of Coleridge and Frost we need to recognise that contemplation is an active engagement with the material object, in which there is an active manipulation of the material elements provoked by the raw motivating force. It is obvious really that there is no room in this for passive withdrawal, but I never saw it. After the initial motivating force the artist does not become a *flâneur* to their own experience, they become workers engaged in the hard task of converting the motivating force into an art work, and the root process behind that conversion does indeed seem, as Clive suggests, akin to a mathematical process whereby space is formed from spaceless chaos.

As a side issue, I cannot help thinking there is another scientific analogy to be made here, this time with the moment of creation. As physicists will tell you, a curiosity of the universe is that it has an edge. The universe does not go on forever, it has an edge called the event horizon. On one side of that edge is all the stars, galaxies and planets. On the other side is nothing, not even empty space. Indeed, it is inaccurate to talk of there being another side, as there is no existence beyond the edge of existence. The most curious thing, however, is that in the moments after the Big Bang of creation (by which we might mean hundreds of thousands of years after the actual 'big bang') the laws of physics that seem to govern every aspect of our existence did not in themselves exist. I do not want to anthropomorphise the universe as I am not a Creationist, but it is almost as though the Big Bang was like a raw motivating force, but there took a period of 'contemplation' for the laws of physics to be established to order that motivating force into the universe we know. This brings us back to the CERN reactor in Switzerland, which is trying to recreate some of that period of 'contemplation', when the laws of physics became ordered into how we experience them today. Again, I am not attempting to create some kind of mystical link between the universe and artistic creativity, it is simply an interesting parallel.

Such comparisons can be dangerously misleading, of course,

but it is notable that in art we do often talk about a painting being an entire universe, bounded by an edge (the frame), outside of which there is nothing that defines the painting within the frame. Is that frame not an event horizon? In the painting there are also laws that govern composition, form and space, that are unique to the painting's universe, but which must be credible. That is not the same as saying they cannot be extraordinary laws, and even the laws of physics in our universe are often just as bizarre and counter intuitive in their workings as a floating Madonna in a painting by Tiepolo, or a naked woman surfing on a scallop shell in a Botticelli; they must, however, be credible within the universe of the painting, and the credibility of those laws is an issue of the construction of credible space.

I mentioned earlier there are two reasons why we should see the creation of credible space in art as a mathematical process, and I apologise for taking so long in getting to my second point. But the second reason is that it offers us a phenomenally strong teaching tool at a time when it is often difficult to know what to teach in art schools. At its most extreme we might suggest that mathematics be taught in art schools, an idea that would probably appal most art students, but which would simply be returning to art a subject that was once at the heart of the art training curriculum. Artists like Piero della Francesca and Leonardo da Vinci were great mathematicians, and they must have learned their mathematics somewhere. If great artists from a great period of art studied mathematics, could the loss of mathematics from art training not be seen as a reason why today we do not live in a land of great artists in a great period of art?

In art training, however, one of the main lessons to be learnt is the ability to self-criticise, or to use a more mathematical-sounding term, to analyse, one's own work. The purpose of this is to find a solution to the problem of that work. Problems in art almost always relate to inadequacies in the construction of space, use of colour, definition of form and organisation of the composition, and in analysing at least some of these is there not a

case to be made that by viewing them as mathematical problems we identify a genuinely useful tool for their resolution? If a painted form does not sit well beside another painted form, or if the angle of a line is failing to define space credibly, then surely it would be a relief to know these problems are not insoluble mysteries. Rather, one has simply to work out the formula that will give the solution.

That sounds like a means of empowering of art, artists and art students in the only way that really counts –empowering them to raise the quality of their work. Indeed, this seems to offer the potential of an exciting new development in art training, whereby we move away from a hit-and-miss philosophy of accidentally-good art, into something more deliberated, which can offer the hope of a new qualitative framework. The proviso with this has to be that in talking about mathematics in relation to art we are not conceptualising mathematics as a series of dry formulae. We are talking about a creative mathematics, the equations of which are created during the contemplative process and are not predetermined. That is, however, something that higher mathematicians claim for their subject anyway. Nor am I trying to turn artists into mathematicians, although I am talking about real mathematics here and not analogies or metaphors. In the dynamic contemplation that I read about many years ago in relation to Coleridge there was an analysis taking place that was mathematical and not quasi-mathematical.

Part 8: The Desolate Forest

The idea of art having a function is a very confused one in our society. I have often heard people who should know better say that the purpose of art is to make you think. There can be fewer more stupid definitions of art. A human being should be thinking anyway, and if it takes someone masturbating in a gallery (viz. Acconci's *Seedbed*) to make you think then you are probably not human at all. You resemble more a computer that needs someone else's input to make you think. Art does not make you think, or at least art does not make you think any more than a paperclip or a budgerigar makes you think. Art does not make you think any less than these either, but unless an historian of philosophy wants to argue that Aristotle's logic is the product of rice pudding making him think, then it is a ridiculous argument that art either *makes* you think, or that its function is to make you think. Art is a material object and like all material objects its relationship to thought is not so mediocre as to initiate thinking.

By the same token, neither is the function of art to make you feel, by which I mean feel an emotional response. If it was then every dead cat lying in the gutter after being hit by a car would be a great work of art. I have seen people so filled with emotion at such a sight they have lost reason, begun to cry and been wholly inconsolable. This despite dead cats being a common sight in Cyprus, where car drivers are incompetent and cats ten a'penny. Emil Nolde would be gnashing his teeth if he thought his art was in competition with dead furry animals to elicit mere feeling. Like the idea that the function of art is to make you think, the idea that art exists to make you feel is so idiotic on so many levels that it is a position that can only be held by people who operate outside of art. Of course they might make things that get called art, and they might call themselves artists; they might even exhibit in art galleries, but they are really no more than the makers of paperclips and budgerigars, rice puddings and dead cats. Or at

best *(worst?)* they are the purveyors of a dictatorial propaganda imaging, forcing us to think and feel according to their diktats, just as Hubert Lanzinger made sure we thought and felt the 'right' things about Herr Hitler. There is a real fascism in claiming for one's art that it is to *make* people think and *make* people feel. What right has anyone to make me think or feel if I do not want to? What right has anyone to say I do not think or feel already, least of all some half-baked fool who claims a right to impose on me?

Of course there is plenty of work that is presented as art that does not aim to make you think. It has the very opposite intention. It is an analgesic that has the effect, if not the intention, of passing off entertainment as art. I think that is the only way we can understand someone like Anish Kapoor. Indeed, Kapoor might well be the greatest exponent of entertainment-art today, and his work does seem to accord with the streak of childish arrested development in our culture. As his astonishingly popular, but essentially vacuous, retrospective exhibition at the Royal Academy in London in 2009 showed his intention is to offer no more than a sense of simple childish pleasure. Although Kapoor's small early works, made from armatures covered in powder paint are usually associated with his Indian origins, and in particular the Festival of Colour, Holi, in the English context they have always most closely resembled piles of school room paint. Consequently the joy of seeing simple primary colours is supplemented by early childhood memories of a time when school meant play rather than work.

Kapoor's machine for firing wads of red wax on to the walls of the Royal Academy was one of the exhibits that received the most media attention. Although most critics suggested it was a highly phallic piece, it was really more like a giant turd joke. Taken on this level Kapoor's work is lighthearted, amusing and entertaining. But it would be difficult for anyone to claim it is profound. It is more like a child playing with a whoopee cushion. Eventually you have to say, that's enough now, go away and play with something else. And I suppose Kapoor did. His piece of

circus fun for the Olympic park in east London, known as *The Scribble,* continues in this slight vein, and even the promoters are not daring to suggest it is great sculpture. Instead they are stressing its role as an elaborate viewing platform to see London.

All of this flimflam hides from the public the level of despair that exists in the real art world, just as dressing up as a shepherdess kept Marie Antoinette unaware of her starving people. In a sense art too is starving, not due to lack of funds, too few galleries, or too few artists. Art is starving because the art world we inherited from the twentieth century was a disaster.

When I have suggested this previously in public I have found myself roundly attacked. There is a kind of denial in the art world, with most artists accepting that art is now in dire straits, but unwilling to apportion blame to those most responsible. The same holds true in art education, where we see plenty of people saying art training is now a disaster in Britain, but when it comes to holding meetings and conferences and journal discussions on what went wrong and what should be done about it, we see the same teachers invited to speak who helped cause the problem in the first place. Or at the very least the same educationalists who did nothing to stop it when it was still possible.[18] Instead the preference is to blame mysterious forces, like third world dictators who blame 'foreign agents' whenever their disastrous rule is threatened. In art education it is always the government's fault, bureaucratisation, increased student numbers, reduced staffing –everything in fact except the possibility that too many art tutors are simply no good.

The poor state of art now is also widely accepted, but again mysterious agents are to blame. Over commercialisation, the dominance of Charles Saatchi, the greedy dealers, the evil arts councils, Damien Hirst. The only real culprit, however, is the one no one seems to want to blame. Given that our art world is a product of the twentieth century, then the twentieth century is to blame. To put it another way, given that our art world is the product of modernism, then modernism is to blame. The only

counter argument to this would have to come from people who think the art world now is wonderful. For the more judicious, however, our art world is not a wonderful place. On the contrary, work of astonishingly poor quality is presented without shame by major galleries as if it is the bee's knees. On any honest measure, whether it is technical ability, integrity, originality, depth of intellectual understanding, or knowledge of the history of art, we have to admit that art is now lost in a kind of Malebolge. And the reason we have an art world that takes people seriously who lack all technical ability, all integrity, all originality, all depth of intellectual understanding, and all knowledge of the history of art is because the twentieth century cultivated an art world that actively demeaned technical ability, integrity, originality, depth of intellectual understanding, and knowledge of the history of art. That was the art world of modernism, and to deny this on the grounds that there were still some good artists in the last century is as ridiculous as defending the Dark Ages in all its brutality because it gave us a few illuminated manuscripts. In general the iconoclasm of the Dark Ages destroyed more art than it created, and the iconoclasm of modernism destroyed more art than it created. Modernism was a Dark Age for art, and because of this it needs to be rejected.

Most of the controversy surrounding my previous suggestions of this centred on whether it is really fair to consign artists such as Matisse and Picasso to oblivion. Interestingly no one has yet argued to me that we need to save Marcel Duchamp or Andy Warhol from the dustbin of history. That might suggest hope that people are already looking back to the last century to recognise things that had genuine merit and things that did not. Unfortunately the things of merit almost all come from before the Second World War, from artists who were largely trained in the nineteenth century. That simple fact alone should tell us something about the nurturing of art in the twentieth century, as well as art education in our own time. It clearly got worse, to the point where we ended the twentieth century with almost no contemporary art

of any value. You only need to look at the tripe made by Sam Taylor-Wood to see how bad art could get in the dog days of the late twentieth century. Because of that we need to acknowledge the moral, practical and intellectual poverty of art now in order to change things for the better in the future. And to do that we need to start by rejecting the twentieth century as it gave us this art world.

But we can go much further than this. As we get further away from the twentieth century it becomes ever more apparent how dull that century really was for art and design. Far from being a radical reinvention of art and design, twentieth-century modernism was little more than an iconoclasm, in which the things that make art, and ultimately life, interesting were methodically trashed. The result was not a brave new art, but an emasculated art made by people who forgot what art really was. Similarly, there was no great new design, only a denuded design that meant every cup, plate, glass, house and office block looked like every other cup, plate, glass, house and office block. Modernist art was a dehumanised art, but like a scene from Orwell's *1984* the twentieth century art world was populated by those who said great art was lousy and lousy art great.

Nothing brings this more to mind than visiting a place like Leighton House, in Kensington. Designed by the Victorian painter Frederick Leighton as his home and studio, Leighton House has always been a special place in London, as a rare example of a museum dedicated to a single artist. But it is more than that. Leighton House was always one of the best preserved Aesthetic Movement interiors in the world, and its survival stood out against the modernist lie that the Victorian art world was dull, dark and moralistic. It was anything but, and the sheer hedonism of Leighton's Arab Hall alone, with its ornate Syrian tiles and golden Greek dome, was always astonishing. A visit to Leighton House was and is a realisation that the art and design world that came after Leighton was painfully ascetic. Only by recognising how Leighton House gives endless aesthetic pleasure in the way

things look and feel, do we start to wonder why the art world of the twentieth century decided to throw all of this away. Leighton House places the experience of being a physical human being in a physical world at the heart of things, and because of that it is a very human and humane environment. So it is not simply a matter of rejecting the twentieth century and modernism for the aesthetic wasteland it has left as our art world, it is to pass judgement on the twentieth century and modernism for the aesthetic wasteland it chose to create for itself.

If we conceptualise modernism from this perspective it becomes clear that modernist art was a kind of half-baked art, incomplete and undeveloped, particularly after the Second World War as the grown up art world that trained the first generation of modernists lost its influence. Post-war modernism was the cultural equivalent of arrested development, and the proof of this lies in looking at the Basic Design Course that came into being in Britain in the 1950s. The leading lights of this new introductory course were Richard Hamilton, Maurice de Sausmarez and most of all Harry Thubron, and its development was centred on the art schools in Leeds and Newcastle. Loosely based on Bauhaus ideas, the Basic Design Course was intended to liberate the thought processes, and the willingness to experiment, of young art students who had been schooled in a highly rigid education system. Later the Basic Design Course was renamed the Foundation Course, and in that form it is still with us today. As a first stage course it is still an excellent starting point for new art students, but the thing that is rarely remembered is that, even in the eyes of its most enthusiastic supporters in the 1950s, students on the Basic Design/Foundation Course were not seen as producing art. That would be as ridiculous as teaching first level music students scales and then thinking they can play with the Royal Philharmonic Orchestra. In art, however, this ridiculous situation has developed. The law of unintended consequences has come into play, and the Foundation Course has had the effect of infantilising higher levels of art practice. Effectively art students now remain

'foundation' students throughout their education, including their degrees, their MAs and on into the increasingly ubiquitous art practice PhD. From there 'foundationism' goes on into the professional art world, so that when we look at figures like Emin, Creed and Hirst what we see are undeveloped artists, still stuck in Foundation Course ways of thinking, and unable or unwilling to develop into mature artists. They show clear signs of arrested development, and the Foundation Course that was supposed to liberate their thinking has actually trapped them. But the shocking thing is not that they are naughty, iconoclastic and childish in what they do, or that they have failed to develop. The shocking thing is that the art world fails to recognise we are looking at Foundation level work when we see what they do. We should expect our artists working now to be as great as the scientists who created the CERN reactor, but instead we celebrate under the name of art people who are the scientific equivalent of an infant school child learning to do her first sums.

Modernism has given us this, but I accept dismissing modernism might seem too radical for some. Radicalism is, however, all a question of timing. In ten years time this view will be common, and in twenty years it will be the majority. But for many of those who have attacked me for saying this now, the twentieth century is still their century, and they are still at heart modernists. That is not to say they necessarily call themselves modernists, any more than Alfred Munnings called himself a Victorian when he railed against Henry Moore in 1949. But Munnings's attitudes were Victorian, and out of step with the modernist era, just as the artists and writers who now refuse to reject modernism are imbued with the attitudes of modernism, and out of step with the twenty-first century. This is a simple statement of fact that can only be rejected by the Canutes among us, but as the twenty-first century progresses the tide will overwhelm them ever more.

This brings us back to the question what is the function of art? This is not so difficult to explain or understand. The primary

function of art is the establishment of credible space. It is impossible to overestimate the importance of this to art, and by accepting it for the truth it is, our understanding of art is fundamentally altered. We have become so used to the idea that art is an assertion that something is art by an artist *or by a viewer* that we have come to neglect the basic truth that an art work is a physical object with its own independent existence. This is not a wilful claim on my part. As rational human beings we rarely accept the suggestion made by extreme forms of idealist philosophy that a falling tree in a forest might not make a sound if no one is around to hear it; but we do seem to accept that an art work ceases to be an art work if no one is around, *or willing*, to assert it is an art work. We have faith that a tree falling in a desolate forest will make a sound because we have faith that the tree has an existence that is independent of ourselves. But we have come to lack faith that a work of art has an existence independent of ourselves for no other reason than we have been told to abandon such faith. We have been told to abandon hope. But the logic we apply to the hypothetical sound of a tree falling in a forest can be applied to the work of art on the basis that if it is a work of art in the first place, it will remain a work of art regardless of our relationship to it. If that is not the case then we need to consider that a thing that requires me to say it is an art work for it to become an art work is not really an art work because it does not possess inherently that status of existence. If I leave Gallery 24 in London's National Gallery either Rembrandt's painting *Belshazzar's Feast* in that room remains an art work because it has that status of existence independent of my presence; or it is not inherently an art work, and it requires me to assert it is an art work to become an art work. If it is the latter then anything can become a work of art through simple assertion, but in the same way we do not readily accept a tree falling in a desolate forest will not make a sound, so we do not readily accept that anything can be a work of art. We are almost at the point at which we do accept this, but that is because of the vast array of dysfunctional

work that is presented to us as art. When we are given a rare opportunity to come face to face with a work of art that is functional, however, whether it is an Old Master like Rembrandt, or a Modern master like Matisse or Frank Auerbach, or a contemporary artist like Clive Head, Thomas Scheibitz or Arshak Sarkissian, we experience a palpable difference that separates functional art, which possesses an independent existence, and dysfunctional work, that requires the viewer to assert it is art. This is not a suggestion that every work of art needs to be a great work of art, nice though that would be. But it is an assertion that nothing is a work of art if it requires the viewer or the art establishment to complete it. Nor does any functional art work require the romantic authority of the artist to say it is art if it really is a work of art. A true work of art proclaims its own status, and will still be a work of art even if global warming or a stray asteroid wipes out human life whilst miraculously leaving all the art galleries standing. Trees will still be tress even if every human vanished from the earth, and art will still be art.

This is what is meant by a work of art that functions. It is a work that establishes its own independent existence, its own reality, and it does that through the establishment of credible space. That is why the function of a work of art is to establish credible space. In essence this means that the space established through the work of art is a reality, a place that is real, that exists independent of our reality. As an independent reality the work of art possesses its own logic, rules and formal structures, which are different to the logic, rules and formal structures that underpin our reality, but which are coherent within themselves. It is through this coherency that the reality of the art work attains credibility, believability or conceivability. Art is not, therefore, simply a picture or an object; it is a bubble of space, established by the artist, but possessing its own independence.

A sense of what this means can be gauged by looking at a Mediaeval map, such as the London Psalter Map, dating from 1250, and now in the British Library. In this we see a circular

globe, representing the Earth, but around the Earth there is another existence, the existence of Heaven. If we conceive of the Earth as a bubble of space, in which the 'artist' has established coherent logic, rules and formal structures, then what we have is the Earth established as an independent 'art work'. The question is, independent to what? Like many similar Mediaeval maps the London Psalter Map gives us the answer to this question very clearly. Outside the bubble of space that is the Earth on the map is shown the 'artist', and the artist's studio assistants, with a depiction of God and two angels. In our time it does not require religious belief to recognise the parallel this map shows to the situation of the artist. Replace God with the artist (and the two angels with the studio assistants, or the latter day version of studio assistants, Messrs. Winsor and Newton or Daley and Rowney) and replace the Earth with the art work, and you have a sense as to what a bubble of space is, and the extraordinary position of the artist. The artist is not a mere conduit for holding up a looking glass to our existing reality, nor is the artist a mere reconfigurer of social signs and symbols. The artist is in a godlike position as a creator of realities. Is that not what we mean when we say that someone is creative, that they are a creator?

And if it seems laughable that any of our current crop of artists should be seen in this light, then maybe the question should not be is this conception of the artist correct, but are they really artists?

Part 9: Body and Blood

I have been wary so far of giving the definition of the art work its correct name, *metastoicheiosis*. *Metastoicheiosis* can seem such a difficult word even to say it might put you off. But it is not so difficult, even if you do not speak Greek. You simply need to break it down into parts. First *meta*, then *sti*, then *hi*, then *oh*, then *sis*. Meta-sti-hi-oh-sis. *Metastoicheiosis* is a Greek word that means trans-elementation, the means by which one material can become something else. It is used in the Orthodox churches to indicate something similar to transubstantiation in the Catholic church, although there are important differences I shall come on to. To the artist, however, the idea of trans-elementation should be standard fare, as all art is essentially an act of trans-elementation, the turning of paint and canvas into a painting, a stone into a sculpture and so on. The important thing about *metastoicheiosis* is that in Orthodox belief it does not just indicate that one material has become another, it also establishes the independence of the transformed object.

The easiest way to explain this is to look at one aspect of Christian belief, the eucharist, or Holy Communion. The eucharist is celebrated in churches all over the world every day, and it remembers the moment at the Last Supper when Christ gave bread to his disciples and told them to eat the bread as it was his body. He then gave them wine and told them to drink the wine as it was his blood. Although there is a common origin for the eucharist in all churches, it has a different meaning in different churches. In the Protestant churches the eucharist is an act of consubstantiation, which means the bread and wine are seen as symbols of Christ's body and blood. In the Catholic Church the eucharist is an act of transubstantiation, which means the bread and wine are consecrated by the priest saying a prayer, and they then become literally Christ's body and blood. In the Orthodox Church the eucharist is an act of *metastoicheiosis*, which means the

bread and wine are literally Christ's body and blood, but without the need of the priestly assertion. In Orthodoxy the bread and wine have an existence as body and blood independent of the presence or actions of the priest. All that is required is faith. That is why *metastoicheiosis* in religion is most like the act of establishing credible reality in a work of art. The art work is another reality, existing within a bubble of space, regardless of the assertion of the artist, just as the bread and wine are the body and blood of Christ regardless of the act of assertion (consecration) by the priest. Of course the artist has to be present to create the work of art, but that is not the same as saying the artist authorises the description of something as a work of art. The base materials of art become a work of art through an auto-assertion, proclaiming themselves to be a work of art because they function as a work of art, regardless of the wishes of the artist, or viewers, or the self-appointed elites of the art world. By equal measure base materials that fail to function as art are incapable of proclaiming themselves to be a work of art because they are not works of art, no matter who wants to say otherwise. Art is art because it is, not because we say it is; art is *metastoicheiosis* and not transubstantiation.

The extraordinary thing about having this faith in art is the unlimited freedom it gives the artist. Rather than constantly and monotonously repeating signs and signifiers of this world, the artist is given *carte blanche* to create new worlds, new realities. Even that phrase, *carte blanche*, seems to cry out for an understanding of art that is based on these principles, meaning literally blank paper, on which we do not need to illustrate or repeat hackneyed visual, political, social or cultural statements from the world around us. We can create any reality we want. The only stipulation has to be that it functions as a reality, a real place that might look to some extent like our reality, or which might be wholly fanciful. Art has always done this, from the realism of Robert Campin and fantasy of Hieronymus Bosch in the fifteenth century, to the realism of Richard Estes and fantasy of Thomas Scheibitz now. All are alternative realities (or we might say functioning spaces) that exist

independently to our reality and our space. The artifice of art is not the lack of credibility of the art work, it is its credibility which comes through its success in functioning as something that is conceivable.

At this point I can hear the objection that if art is not an illustration of political or social conditions, if it is not a reflection of our world, is it not just an act of escapism? In part art is an act of escapism, and earlier I described my personal experience and need for asylum. But we also have to put into the ring the claim made by the great German philosopher Wilhelm Worringer that the function of art was precisely to enable the mind to escape from the terrible flux and arbitrariness of actuality: 'For primitive man —still mentally undeveloped and therefore contemplating the chaos of the world surrounding him with timidity and doubt— artistic activity... meant the impulse to establish another world of perceptual values, a world of absolute and permanent values, placed above the shifting world of appearances and free from the arbitrariness of life.'[19] When Matisse talked about wanting his art to be like a good armchair, wasn't this what he meant? If we lived in an age when the horror of life was hidden from us, a case *might* be argued for art having a role in redressing the balance the other way, making us face up to that which we wilfully ignore. But artists delude themselves if they think by making their work illustrative of the horror, injustice and inequality of the world they tell us things we do not know. We all have access to the Internet, the BBC or CNN, or we experience it in our everyday lives; the artist illustrating horror merely states the obvious. Often they are far worse than that; they rub our noses in the worst of what we already suffer. In an age like this, therefore, a case can be argued for art having a role redressing the balance, providing a good armchair into which we can escape from the horror. Or, to put it another way, art is again needed 'to establish another world of perceptual values, a world of absolute and permanent values, placed above the shifting world of appearances and free from the arbitrariness of life.' When I can watch in my own front room live

scenes of people dying what can art do to add to the dread? Its only real function can be to ameliorate my fear, to allow me to function without a debilitating sense angst. The function of art is to help me survive as a human being with my humanity intact. The function of art is never to diminish humanity.

And yet I also reject the idea that art is an act of absolute escapism from this world. If we return to the London Psalter map, such aesthetic objects were conceived as intermediaries between Heaven and Earth. Through them you could visit Heaven, just as surely as you visited Heaven when you kissed an icon of a saint in church. And having visited Heaven the 'viewer' was returned to Earth a changed being. A better being. Remove the religious aspect from this and the effect is surely the same in our art. Look at a Cuyp landscape, a Rembrandt portrait or a Cubist still life and you enter another world. Returning from this, one is changed, just as one is changed by visiting a foreign country, meeting people of a different culture, experiencing their environment and their way of life. In this respect the art work becomes the most foreign country of all, not just another place on Earth, but a whole new reality, one that allows escape from the arbitrary horror of this Earth. It changes the mental attitude of the viewer on their return, and so to view art is to undertake an astonishing act of time travel, spatial travel and even dimensional travel, all of which must surely change those who experience it.

Given that extraordinary power, astonishing freedom, and the grave importance of art to the survival of the human species, I cannot help wondering why anyone would bother to challenge the nature of art by making non-art.

Endnotes

1 See Peter Bürger, *Theory of the Avant Garde* (Manchester: Manchester University Press, 1984) 49

2 See Jules Prown, *Art as Evidence* (New Haven: Yale University Press, 2002) *passim*

3 Susan Sontag, *Against Interpretation and Other Essays* (New York: Farrar, Straus, and Giroux 1961) 14.

4 Herbert Read, *The True Voice of Feeling* (London: Faber and Faber, 1953) 33-36.

5 T.E. Hulme, *Speculations* (London: Routledge, 1924), 116.

6 Enjoy this futile task for yourself in Roland Barthes, *Image/Music/Text* (New York: Hill and Wang, 1977) 33-7.

7 See Ashley Montagu, *Touching: The Human Significance of the Skin* (New York: Columbia University Press, 1971) 163

8 I believe this rule has now been changed under pressure from the European Union against restrictive practices in employment!

9 Wilfred Bion, *Learning from Experience* (London: William Heinemann, 1962; 1991 reprint), 17.

10 I have discussed this at more length in Michael Paraskos, *The Elephant and the Beetles: The Aesthetic Theories of Herbert Read*, unpublished PhD (Nottingham: University of Nottingham, 2005) 159f

11 Preface to S.T. Coleridge and William Wordsworth, *Lyrical Ballads* (London: Longman and Rees,1801)

12 Herbert Read, *The True Voice of Feeling* (London: Faber and Faber, 1953) 35

13 John Ruskin, *Modern Painters* (London: Smith, Elder and Co., 1843) vol. 1, part 2, 416-7

14 Patrick Heron, 'Space in Painting and Architecture', reproduced in Mel Gooding (ed.), *Painter as Critic, Patrick Heron: Selected Writings*, (London: Tate Publishing, 1998) 73

15 See James W. McAllister, *Beauty and Revolution in Science* (Ithaca, NY: Cornell University Press, 1996) 90f

16 Theo A. F. Kuipers, 'Beauty, a Road to the Truth', in *Synthese*, vol. 131, No. 3 (Jun., 2002) 291

17 See James W. McAllister, *Beauty and Revolution in Science* (Ithaca, NY: Cornell University Press, 1996)

18 For example see the discussions organised by the magazine *Art Monthly*, at the Institute of Contemporary Arts, London, on 27 September 2008, and the Ikon Gallery, on 6 October 2008. Most ridiculous of all, for a real lack of self-awareness see Steven Henry Madoff (ed), *Art School* (Cambridge, Mass: MIT Press, 2009)

19 Wilhelm Worringer, *Form in Gothic* (London, Putnams, 1927) 29

Lightning Source UK Ltd.
Milton Keynes UK
30 October 2010

162126UK00008B/4/P